Western Pennsylvania Reflections

Western Pennsylvania Reflections

Stories *from the* Alleghenies to Lake Erie

—◦ *Edited by* ◦—

Colleen Lutz Clemens and Rebecca Helm Beardsall

THE
History
PRESS

Published by The History Press
Charleston, SC 29403
www.historypress.net

Images are courtesy of the authors unless otherwise noted.

Cover images: Strolling. *Amanda Lynch Morris, 2007*; View. *Amanda Lynch Morris, 2007.*

First published 2011

Manufactured in the United States

ISBN 978.1.60949.317.2

Library of Congress Cataloging-in-Publication Data

Western Pennsylvania reflections : stories from the Alleghenies to Lake Erie / edited by
Colleen Clemens and Rebecca Beardsall.
p. cm.
ISBN 978-1-60949-317-2
1. Pennsylvania--History, Local--Anecdotes. 2. Pennsylvania--Biography--Anecdotes. 3.
Pennsylvania--History--Anecdotes. 4. Pennsylvania--Social life and customs--Anecdotes. I.
Clemens, Colleen. II. Beardsall, Rebecca.
F149.6.W45 2011
974.8--dc23
2011031265

For Dwayne and Weasel

Contents

Acknowledgements

We are both thankful for our Pennsylvania heritage and for our parents—Robert and Marilyn Helm and Sandra and Barry Lutz—for raising us in the tradition of the Pennsylvania German community, which cultivated our work ethic and love of Pennsylvania.

We appreciate the honesty, patience and talent evident in all of the writers who generously shared their memories and stories of Pennsylvania. Reflecting on the past is never an easy task, and we are grateful that they were willing to take that journey with us.

Finally, we would like to thank our partners, Matthew Clemens and Geoffrey Beardsall, for listening to book talk over many a Sunday breakfast. Without your relentless support, this book would not exist.

Introduction

Almost thirteen million people live in Pennsylvania as of 2010. They spread out over forty-six thousand square miles. Some of them live in the middle of the state in Happy Valley, where they can hear cheers celebrating a Nittany Lions touchdown from a mile away. Others fall asleep to the sounds of peepers that serenade Bucks County residents in the spring. In the fall, neighbors in Hazleton hear children jumping into piled crisp leaves. And in the winter, residents of Erie might hear nothing but the swoosh of snow falling.

Pennsylvania is not only the Keystone State, which was crucial in the founding of this nation, but it is also the keystone to the lives of Pennsylvanians. It is our relationship with the towns, cities and farmland of Pennsylvania that grounds us and provides the support for our livelihoods. Our lives have been shaped by the values, cultures and traditions established in this great state. Coming to an understanding of our sense of place is important to how we view ourselves. This collection of creative nonfiction about the land, people, towns and cities of Pennsylvania was created for us to remember our history and heritage and to honor our present-day lives and accomplishments. The state represents a wide range of individuals; each holds his or her own stories and memories. Even though jobs or families may take Pennsylvanians from their home state, the connection to the place remains.

In 2005, along with two other Pennsylvania writers, we presented creative nonfiction essays focusing on the land of Pennsylvania at a conference. We realized our panel could be the beginning of a larger collection that would

present readers with a full view of Pennsylvania's regions through the eyes of some of the state's best nonfiction essay writers. As two lifetime residents of Pennsylvania, we are proud to have edited two works that reflect the beauty, work ethic and tradition we see in the Keystone State: *Philadelphia Reflections: Stories from the Delaware to the Schuylkill* and *Western Pennsylvania Reflections: Stories from the Alleghenies to Lake Erie.*

We wanted to hear the stories from these thousands of square miles, the stories that come up from out of the ground of the mines and from the mills, from the stadiums and the stables, from the fire halls and the fishing holes. We invite you to share in stories from the state, to linger in the spaces you find comfortable and to learn something new about your neighbors, who live on a different square mile. Let this book serve as a keystone that holds all of us—residents and transplants alike—together.

Something Old, Something New

Lawrence County

By Thom Tammaro

When the cornerstone of the new addition to that great brick and limestone Church of the Purification of the Blessed Virgin Mary—the church of my Catholic youth in Ellwood City, Pennsylvania—was blessed on that Sunday in April 1940, the dedicatory sermons were preached in English and Italian. What made it all the more wonderful was that stepping from the main church doors onto the steps of the Italian colony's newly remodeled edifice that afternoon, the proud Italian parishioners only had to look across the street to see Henry Waters Hartman's public school. The namesake of the man, a former partner of Andrew Carnegie, who sold some of the parishioners' fathers and mothers the undeveloped land outside the city's limits to keep them away from the rest of the townsfolk, now shared the same city block with the "dusky foreigners'" house of worship. The "dusky foreigners," as they were once referred to in a newspaper account of the time, were sold the land across the county line, where there would be no roads, electricity or sewers for another thirty years. Had Henry Waters Hartman been alive and walking the neighborhood that April afternoon, he would have heard the beautiful soprano voice of Amelia Cerriani—along with the accompanying organ music, which was electronically amplified from inside the church—swirling and winding its way through the heavenly afternoon air.

This newly remodeled building would be the Catholic church of my boyhood—the church where I would be baptized eleven years later, make my first confession (I always added an extra number to my tally of sins

just in case I gave the wrong number), take my First Communion and stand for Confirmation when I became a Soldier of Christ. It would be the church where, as an altar boy, I would serve hundreds of daily and Sunday Masses, including wedding and funeral masses, and assist with baptisms after 12:05 p.m. Sunday Mass.

With stained-glassed windows; plaster statues of saints with horrific, bloody gashes carved in their thighs and plucked eyeballs in the palms of their hands; and snow-white Carrara marble altar rail and floors—this was the church of my youth, where, as an altar boy during Holy Week, I carried three-foot tapers in their golden sticks, thick and long as baseball bats, during the Stations of the Cross. This was the church where I stood and knelt in awe when the Capuchin monks came to chant in Latin the Litany of the Saints during Forty Hours Devotion. And this was the church that I watched razed with a wrecking ball one afternoon in 1969 after it was desanctified and stripped of its windows, its statuary, its Carrara marble and its great wooden pews, the surfaces of which had been worn smooth as any fine Italian silk. The mission that was established in 1917—with the specific charge to minister to the Italian colony of two hundred families and one thousand parishioners—had, by 1969, swelled to over twelve hundred families and nearly five thousand parishioners.

<div align="center">⊷⊶</div>

In the mid-1960s, the local church fathers and the Diocese of Pittsburgh decided that the 1940 structure was too small and too costly to repair or remodel again, so they voted to build a new, more modern church, whose interior and exterior design and architecture would reflect and incorporate the progressive spirit of Vatican II. Of the new building's interior design, the *Ellwood City Ledger* reported that there were to be none of the "trappings" of an earlier age—stained-glass windows, a preponderance of statues and ornate embellishments of the altar. The emphasis, the article reported, was to be on the physical comforts that the old church did not provide— air conditioning, a vast loudspeaker system, restrooms in the vestibule and electrical snow and ice removal around the church walks. The Catholic Church had survived the Crusades, the Spanish Inquisition, the Great Schism of AD 1054, the Reformation and Counter-Reformations for nearly two thousand years. Suddenly, we had to free ourselves of the trappings of an older age and make way for air conditioning, loudspeakers, bathrooms

and heated sidewalks—the trappings of the modern age. I wondered then, as I do now, who was really being trapped.

Without its fifty-foot bell-tower with Angelus bells, this new building might be mistaken for any number of undistinguished-looking government office buildings, where bureaucrats go to do their bureaucraty things. This square, tired-looking gray concrete building was constructed in the postmodern style, one might say, though no one used the term back then. Gone were the steps rising to meet the doors, where members were literally above ground level, feeling as if they had left this earthly plane and ascended to a realm somewhere between earth and heaven. Gone were the stained-glass windows. Gone was the Carrara marble and marble altar rail. Gone was the plaster and marble statuary. Gone were the tiered altar space and the ornately carved white wooden altar, which always looked as though it was floating above the floor. Replacing it was a five-ton block of smooth black marble. The altar hunkered solid and firm on the same level as the worshipers.

When parishioners came to celebrate the first Mass in the new building at sunrise on Easter morning in 1970, they found the old familiarity and warmth of their sacred space replaced by this spare and austere cavern, looking more like a civic auditorium or university lecture hall than a church. Many of the Italian parishioners who had grown up and taken their sacraments in the old church found it difficult to warm up to and embrace the new one. The following Sunday, some of the old-timers were found taking their Masses in the gothic limestone church of St. Agatha about a half mile away.

———◆◆◆———

In the arc of history between 1885, when Italian immigrants began arriving in Ellwood City, and 1969, when the new, post–Vatican II parish church was sanctified, something more than a building had been lost and replaced. When the sermons were delivered on the afternoon of the new church's dedication, they were preached in English only, though the presence of the original Italian colony continued to be evident in the presence of those who presided: Father DeBlasio, the current pastor; Father Biondi, a former pastor; Monsignor Fabbri; and the vicar and general chancellor from the Diocese of Pittsburgh, Monsignor Anthony Bosco. The mix and tumble of Italian and English vowels and consonants—which bounced their way through my hometown and my youth, causing Irish St. Agatha parish to split and the Italian colony Church of the Purification of the Blessed Virgin Mary to be

built—was gone. Gone, too, was the Latin Mass, which I learned as a young boy and which served as a kind of linguistic thread that stitched me to my childhood classmates and friends, who spoke Italian because their families permitted Italian to be spoken in their households—unlike my parents, whose own parents had prohibited them from speaking the language of the old country while growing up for fear that they would be identified as the son or daughter of a dusky foreigner and kept from the American dream.

By 1980, however, the postmodern structure began showing premature signs of deterioration, including the roof, which began to leak shortly after its completion. Thin-walled construction cried out for soundproofing, and an inefficient, costly and poorly designed recessed lighting system begged to be replaced. In less than ten years, the freestanding Angelus bell tower began cracking. Its postmodern architect forgot to cap the tower walls with a deflecting material, allowing water to run down the sides of the concrete structure. Consequently, tower sections had to be cut and replaced. Had the tower's designer consulted any number of the parish's immigrant Italian stone masons, he would have been warned of this potentially dangerous flaw.

The sparse, minimalist church interior and altar space began to reshape itself, too. Postmodern screens, originally suspended above the altar—perhaps suggestive of the icon screens of the old Byzantine altars—were eventually replaced by a larger-than-life crucifix, which, too, was suspended precariously above the altar. The figure of the Giacometti-like Christ, draped with loincloth, hinted of the statuary adorning the older churches.

Even Pastor Dascenzo's mother got caught up in the remodeling of the new church by donating oak trees from her backyard, which were hewn into beautiful planks, shaped into panels and placed behind the altar. With the crucifix, the panels drew and focused a parishioner's eye toward the altar's center, unlike before when the eye was left to roam the cavernous interior space. The lobby was remodeled, and new doors were designed and set in place. The modernist Madonna and Child metal design on the door's glass suggested stained-glass patterns. Parishioners remarked that a wonderful-looking church was made even more spectacular, though I suspect they meant that the building was finally looking more than ever like their old church.

<hr />

Not long ago, my mother sent me a clipping from my hometown newspaper reporting the discovery of the original stained-glass windows from the

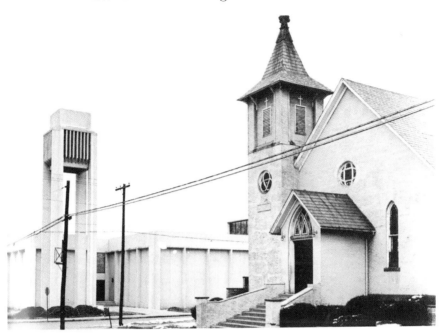

Purification of the Blessed Virgin Mary Churches, circa 1969.

remodeled 1940 church in the basement of a nearby church. Plans were being made to restore as many of the windows as possible and to display them as decorative panels rather than functional windows in the new church. A piece of Carrara marble was also found, and plans for its restoration and display were being discussed.

Last year, during a Christmas visit home, I attended Mass on Christmas Day. I wasn't surprised to find that a few statues had found their way into the church and that modern Stations-of-the-Cross panels graced the north, east and west walls. Near the baptismal font and lobby, I spotted the stained-glass windows, framed in wrought iron and suspended from the ceiling, catching the late morning light, spreading Chartres blue hues around the baptistery. And a snow-white section of carved marble, also framed and suspended with the windows—relics from another era—carried me to another time and another church. Perhaps something was returning; perhaps something had never left.

Predatory Youth

Bedford

By Michael Hyde

COONING

Untethered and on the scent, a beagle or coonhound transforms from the puppy plaything of daytime to a bullish nighttime hunter. Now they move in a group of four—Manfred, Judy, Lady, Santa—spreading out through the trees, their howls filling the round sky of the valley. Subtle differences emerge: Lady, the leanest, is also the fastest, taking charge. Santa, the oldest, the most easily distracted, stops to sniff an errant scent and dawdles in marking the nearby oak. The night feels like tinsel—clear, crisp—and it is well past my bedtime as we hunters stomp down through a cornfield, steer away from the gurgles of a stream and follow the pulsing thrill of the dogs.

This is my first time on the hunt. I am seven or eight, and for a moment, wearing a helmet with a light bulb atop it outweighs the potential excitement of finding a raccoon. With a twist of a switch, the whole dark of the forest illumines in pale blue, the light from the cap making the dark beyond the fan of light seem darker, as if darker things—Bigfoot even—might be hidden and waiting there. Light, no light. Light, no light. My father yells at me to stop doing that, that I'll scare away any raccoons that might be sneaking nearby. I learn there are rules to this: lights on only when the dogs have found something. And there is a science to lifting my foot and putting it down, my father tells me, showing me how to step softly on a branch without

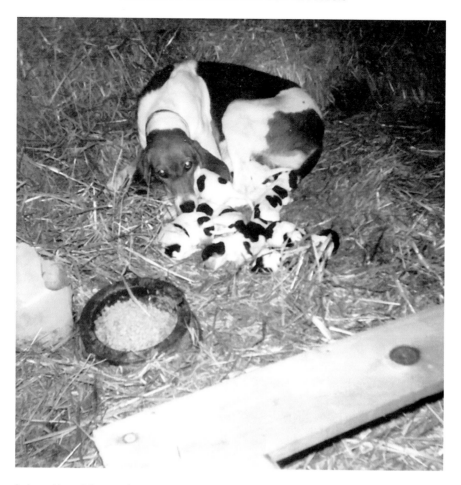

Judy and her eight puppies.

making it snap, how to lift the foot to keep the forest floor undisturbed. Then I am taught to listen: the quality of the dogs' barks tells us when something has been treed.

I stay close to my father, who carries our gun. My grandpap, Uncle Walt and Uncle Eppy keep moving through the trees. Already I have the sense that my father feels some guilt and embarrassment, that I'm learning too late this science of hunting at night. "City slickers," my grandfather and uncles tease my father and me. "City slickers"—even though we have moved only a few hours east and are in proximity of horses and buggies and surrounded by cornfields of our own. Still, to them, we have made ourselves outsiders, and moving down from the mountains, we are city.

I let my father move on ahead of me. Light, no light. Light, no light.

The dogs have now circled back upon us, as if to make sure we are where they would like us to be and to be told that they are good dogs, good dogs doing a good job. Though out of breath, saliva dripping from their mouths and their tongues, they plunge again into the night.

They have found something. Hear that howl? We are rushing forward through the forest. *Snap! snap! snap!* I go and cringe, and now it's time to turn on the lamps for real. This night, we have not found a raccoon but a possum, staring down at us from the treetop with the face of an old woman, hissing, as if to say, *How dare you, this is mine, get out! Go!*

Small Game

There is one moment, in the kitchen, when my father's hunting vest, bulging and full, is magic as he produces ruffed grouse and rabbits from the vest pockets, as if giving birth to these forest creatures extracted from his torso, all of the animals unfolding themselves in feathers and fur as he presents them to me with both of his hands. What a treat to have these small animals indoors, I think, only to realize these are just their shells, their wildness gone, a fact made clear by the dried drop of blood tucked in the corner of each of their mouths. I want to pet them, but I don't want to look at their faces, which have soured with the angry last pitches of their lives. The birds do not bother me as much as the rabbits. We have two rabbits of our own—Snowball and Chocolate Marshmallow—plump domestics that move leisurely and, in warm weather, love to daydream in the yard while chomping on blades of grass. Yet here are their smaller brown cousins, soon to be fried or made into potpie.

While other kids my age dream of becoming firemen and astronauts when they grow up, I possess a short-term aspiration to pursue life as a rabbit. A rabbit is built for speed and sneak, qualities I prize in myself. I can outrun everyone my age but one other boy at recess, and I love playing practical jokes, sliding close to a wall, getting close and yelling, "Boo!" or "Surprise!" I make the mistake of telling a classmate about wanting to be a rabbit, which he thinks is stupid because I'd get eaten by everything: wolves, bears, dogs, humans. "I'll run!" I tell him, and even if he doesn't believe it, I know it to be true.

Now it is morning. There's snow, not too cold but cold enough to make me shiver. The morning has been presented to me as a walk through the woods with my father and my grandfather, whom we call Pap, and Uncle

The author's grandfather, uncle and an abandoned house.

Don—this time with my father's side of the family. I slide into my rain boots and my navy coat with the fake fur hood. We are with Sarge, the beagle, who is usually tied to the red dog box by a long chain that has made a grassless circle from his constant pacing. He is rarely loose, and his joy is obvious as he darts about the yard, through a line of shrubbery and makes a circle around the house before we are off toward the woods.

"What are the guns for?" I ask. "Aren't we going for a walk?"

My father, Pap and Uncle Don are wearing their orange and tan hunting vests with orange hats that glow like flames, especially against the frosty morning air.

"Just in case," someone says. By this time, I'm well versed in the 1967 Patterson-Gimlin Bigfoot video from Bluff Creek and have seen *The Legend of Boggy Creek* enough times to know how quickly a nature walk can turn into something terrible, so I don't question any further. Based on the research I've done reading in the tiny library of my elementary school, Bigfoot hasn't been sighted in Pennsylvania, but a person can never be too careful.

We round the top of a hill, and my grandparents' house disappears. I love the sound of crinkling ice and snow underfoot, and Sarge the dog goes wagging off before us. He's slower, more deliberate, more distracted than a hunting pack. For large spans of time, we do not even see or hear him,

The author, age eight.

but we know he's there. Trees, trees, trees and now a path that leads to an abandoned barn made from blackened wood and then a house. "Who lived here?" I ask. "Where did they go?"

We peer through the dark window glass, and I want to rush open the door, ascend the spiral staircases I know must be numerous here, as they are in old farmhouses, but I have learned any abandoned place will be filled with snakes, a great writhing mass that will drop from ceiling rafters and coil in the victim's hair. My pap says a name, German in origin, not someone we know, gone before our time.

Then we are crossing a field to an area of briars and thorns that, in summer, would be filled with blackberries, buckets full, enough that I can eat handfuls myself and still have too many to return for Grandma to bake into

a pie. "Take a look there," Pap says and points beneath a spiral of bramble that curls up from the ground like a seashell. There, beneath the briars, sits a small cottontail, still as can be, its black eye upon us, its legs tucked beneath it, ready to spring. Sarge seems nonplussed and skirts the ground behind us.

"Here, take a shot," my grandfather says, handing me his gun.

"I'm not holding it," I say.

"You don't even want to try?"

"No, not even try." I know holding it will mean pulling the trigger, so I hide behind a tree. I feel the bark press into my face, which hurts but reminds me of who I am, and in my head, I'm saying, *No no no no no no.* I wait to hear a gunshot. Today, however, none comes. We have a fine walk in the woods, and even though I feel victorious—*A rabbit lives!*—the disappointment my father feels is doubled by the disappointment I know my grandfather and uncle must also feel. We return to my grandparents' house, thawing from the snow, but still inside me has formed a tiny shard of ice, an icicle that promises to remain. I wish I could be the boy-warrior they want me to be, for so much of my childhood is frozen in shame from not pulling a trigger. Settled in, warming, I feel that ice. Even when my uncle buys me my own rifle for my sixteenth birthday, as he has done for all boys in the family when they turn sixteen, I never open the box. It sits in a closet, unused, gathering dust. Maybe it will still be there someday when the house becomes empty and abandoned of everything else.

SHROOMING

This I can handle. It has all the things I like about the woods: trees, animals, looking closely at the earth. It is a story with a beginning, middle and end but without the guns. We are the treasure-seekers, and after a night of heavy rainfall, there is certain to be treasure.

This time it's just my dad and me. I know that in the world where my father lives, fathers and sons quite naturally spend all of their free time together, hunting things, and I doubt he ever realizes until I tell him years later that my choice to spend time with him is just that, a choice and compromise made against other things that might bring me joy: Saturday morning cartoons, reading up about monsters, building forts for my action figures and connecting them via a series of zip-line cable cars strung from one side of our basement to the other. For many years of our lives together, my father's and mine, as close as we are, we stare at each other across a widening divide.

"What do they look like?" I ask him.

"Like mushrooms. Just don't pick the poison ones," he says.

"How do I know which ones are poisonous and which ones aren't?"

"Ask me," he says.

Finally, here is this sense of danger I have been looking for, as I imagine myself touching a poisonous mushroom, succumbing to deep sleep and waking hours later in a different world. The swampy spring of mushroom season also aligns with tick season. I know there are good years and bad years for ticks, and already I have heard that this is an especially bad year, so the morning seems doubly dangerous.

"I should have brought different bags," my dad says, "but these were all we had." He hands me an empty Stroehmann bread bag, long, plastic, rising in the wind. He utters this regret the first time we go mushroom hunting, and he will say it again each time we go mushroom hunting thereafter, always regretting not having proper burlap sacks so that spores from the picked mushrooms can drop and spread as we move through the woods. We see a deer, a turkey buzzard circling, a red newt by a stream.

"Who do you think is stronger, Bigfoot or the Yeti?" my dad asks.

"Bigfoot definitely," I say.

"Bigfoot or Dracula?"

"Bigfoot, no contest."

My dad tells me the story about the time he saw Bigfoot, a story I will ask him to retell throughout my childhood. He was crossing to his grandfather's when he was a little boy to get milk for the morning when he heard a terrible sound, a crackling and a howl that when he makes the noise sounds like a cross between a static radio and a terribly sad wolf. He was frozen with fear, terrified, not able to move, hearing only that sound and something moving through the woods. Fortunately, my great-grandfather's house wasn't far away, and my dad was able to run for the house, dropping the milk bucket, though, in the process. When he went back later, with my great-grandfather, a shotgun and a flashlight, something had ripped a hole in the bottom of the bucket.

"Why do you think it did that?" I ask. "Why would Bigfoot tear a hole in a bucket?"

"He could probably smell me on it," my dad said. "He could probably smell me on it and thought it was me, so he tore into it."

We walk a bit farther with our bread bags. I'm staying close to my dad now, and he says, "Down here." I come to where he means. I see it, yellowish gray and rising like a tiny brain poked up through the earth: our first morel. "Pinch it off between your thumb and forefinger," my dad tells me, "so that

the root stem can grow back and produce another mushroom. Where there's one, there are usually others."

And there are. Another, and another and another, growing in clusters so close. I pinch them carefully, inspect for their hollow stems that tell us these are good to eat and not the densely-stemmed poison we are hoping to avoid. Soon our bags are full, and even though they don't look like any of the mushrooms I have seen at the supermarket, they taste wild and delicious, thrown together with butter and meat stock. As we sit eating and telling my mom how we found them, I say, "Hey, Dad, tell that story again about the time you were a boy and saw Bigfoot."

GOLF BALLS

"Let's gather ourselves up here and go golf ball hunting!" my grandpap says. *Golf ball hunting?*

Soon, he and I are loaded into his pickup truck, the one with the floor rusted through on the passenger side that he's covered with boards, and we are speeding away from the farm, up the lane and toward what he and the rest of my family refer to as "The Springs," meaning the Bedford Springs. At this time, the Bedford Springs Hotel is almost two hundred years old, with over two hundred rooms, and although we can never seem to remember which U.S. presidents have stayed there, we know there have been several. The Bedford Springs Hotel reminds me of the hotel from *The Shining*—so many rooms, with so many secrets. It would be easy to get lost there, and as we round the corner, it is always there, rising like a monolith, one that I have heard has passed from owner to owner over a period of rough times. I know from my mother that she had her high school prom there, when people would come from miles to sample the spring water or be rejuvenated by soaking in the mineral baths of the Bedford Springs. When my grandpap says "The Springs," though, he doesn't mean the hotel but the golf course attached to the resort instead. Being a local, and a golfer, he's much less interested in the hotel than the eighteen holes of well-kept greens.

He turns down a dirt road that takes us to the middle of the course, a tractor shed that is in sharp contrast to the whitewashed clubhouse on the other side. In exchange for repair work he does on golf carts and all things mechanical, The Springs lets him play rounds of golf when the course isn't busy with paying customers. Today, though, we're entering through this back entrance, no golf clubs in tow, pulling to a stop at the machine shed that looks out of place with its manicured surroundings.

"Let's walk here, over along the trees," Grandpap says, "and then down by the stream. Balls get hit into the water, and those people are too lazy to fish them out."

I'm surprised at how many we find so quickly, a bucket full of balls that have skittered into the weeds or the woods or the stream, golfers not wanting to go far from the fairways or the greens, or maybe not good at finding their lost golf balls once hit from the clear path. I find a bright lime green golf ball that my grandfather says I can keep. The others we have found, I'm surprised to learn, he'll take back to the clubhouse at some point and sell for money. I don't tell him I was hoping to keep all of the balls I have found for myself.

"Let's see if we can get another pail full," he says.

I'm moving along the trees, down through a stream, rocks slipping and popping beneath me as I cross from one bank to another. I hear the voices of golfers approaching a putting green just beyond the trees. I have the feeling they would not want me to be here, shifting through the trees, picking up what's been left behind, so I crouch down, not wanting to be seen.

One of the foursome is holding a beer. Another holds his putter like a cue stick, as if he is instead shooting pool, and then straightens up properly and taps his ball into the cup for a score. "What did you make on that hole? A five?" Even though they are loud and their faces are red, their golf shirts seem free of wrinkles and are tucked into pants that are as equally loud and colorful. My own pants are dirty and rolled up mid-calf, and my shoes are wet from the stream. The golfers don't see me. I am the hunter and the hunted, the untamed thing, the animal looking back on the human world, mysterious, from the cover of these trees.

Playing Among the Dead and Dying

Pittsburgh

By Sue Kreke Rumbaugh

"C emeteries make great neighbors," our dad used to say.
The people, he reasoned, were in neat rows, edged with beautifully carved stones and adorned with flowers of red, pink, purple and white—no matter what the season. "Best of all," he said, "they don't make noise."

The Homewood Cemetery, at the end of the street where I lived when I was seven years old, lies in Squirrel Hill on the edge of Point Breeze in Pittsburgh and is one of two places we played during the winter months, when the snow was deep and temperatures dropped below freezing in this region of western Pennsylvania.

Frick Park, just beyond the cemetery, was the other. This park, with its beautiful, fieldstone gatehouse entrances on several city streets, has rolling hills and a forest of trees, as well as open fields where we would run and fall, roll and race until we could play no more.

We loved playing here in the summer but even more during the grueling winter months after being held captive indoors in our six-bedroom house, bound by parents' rules that grew by the day, limited access to television and frequent reminders to "be quiet." Unable to play freely, our energy levels rose to the boiling point and began to spill over.

That's when we went outside.

One late morning, after reprimanding us for watching cartoons on our family's black-and-white TV, Dad agreed to drive us and our friends from

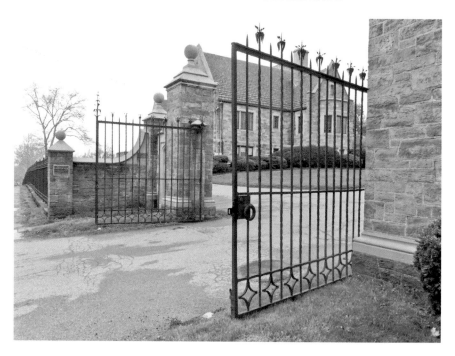

The entrance gate and, behind, the main building of the Homewood Cemetery on Dallas Avenue in Pittsburgh, Pennsylvania.

the neighborhood to Frick Park on Beechwood Boulevard, a mile and a half away, where a long hill flattened at the bottom. We were thrilled that he agreed to take us. We were dressed and seated with our sleds in our family's utility van that Dad purchased to accommodate Mom's wheelchair. As he drove on the snake bends of the boulevard, we taunted one another, betting who would be the first to reach the bottom of the hill.

When we arrived at the park, we spilled out of the back and side doors, like a disturbed nest of ants, and ran for the hill, some of us remembering to wave goodbye to our father. When I turned around, he hollered back, reminding me to button my coat and promising to return for us in time for lunch.

We cut through the bushes to the top of the hill, where I stopped, looked down and thought, *No way*. The hill was too steep for me. I began arguing with my brother, who told me to stop whining and get going. As I stood, debating and crying, I realized that there was no backing out, and within minutes, I was lying on top of my brother's back next to a line of other sled riders preparing for our first race. As we pushed off, I held on, squeezing the shoulders of his coat and screaming from fear that

made my heart pound. I felt certain I would die if we crashed on our way speeding down the hill. As we neared the bottom, he took a quick left to escape a collision with another sled rider and to avoid a log lying in our path, one of many fallen trees scattered here along with boulders and rocks that jutted up through the snow.

When we all stopped, we rolled off our sleds, yelling at one another, arguing about who won and laughing from the thrill of the race. I brushed the snow from my wool pants and coat, slapped my mittens together and headed back up the hill. "Last one up's a rotten egg!" someone shouted. I protested that it wasn't fair. I knew it would be me, the youngest.

We did this loop, time after time. Lying or sitting on sleds, pushing ourselves off with our hands or feet, riding all the way to the bottom only to climb back up and slide down again. As the day progressed, we became more daring, running and diving onto our sleds for extra speed. On the way down, we steered around ruts to avoid crashing and toward bumps to lift us to fly through the air. Then we'd get off and trudge back up the hill, digging our toes in for traction, while pulling our wooden sleds with metal blades behind.

After a couple hours, when our driver returned, we resisted. "Aw, just one more!" we asked, and he agreed, watching and waiting until he ran out of patience. Once home, we waved goodbye to our neighbor friends and then filed inside to the warmth of our house. Our cheeks and hands were bright red; we sat on the hallway carpet and peeled off our layers. We draped our wet gloves, hats and socks on the radiators throughout the house and hoped they would dry quickly.

Then we sat together around the kitchen table, eating our hot soup, peanut butter and honey sandwiches and milk. The hard, plastic plates of muted beige and green clashed with the sharp, shiny colors of our metal tumblers. As we ate, we told our father the stories of thrilling races, running, crashing, rolling, shouting and me crying, until we were all talking at the same time, which Dad hated, so he spoke loudly, trying to quiet us. When he finally yelled, "Enough!" louder than all of our voices combined, we calmed down and ate in silence.

When lunch was finished, Dad led us in prayer and assigned each of us a job: carry the dishes to the sink, sweep the floor, wash, dry or put the dishes away, take out the garbage—anything to make this meal a family project and help with the cleanup. We did so, reluctantly.

Then we were off to play again. After an hour or so, I was bored and complained that there was nothing to do; others agreed.

Dad intervened. "Go read a book!" he said in his professorially commanding way, hoping for us to be less play oriented and more scholarly. His voice, sincere at first, turned desperate on the third and fourth pleas for silence in our house, which was kept quiet and dark. It had to be, for Mom's sake, he explained, because of her multiple sclerosis. When we finally understood this necessity, his voice had become so loud it crackled, the veins on his forehead bulging with frustration and anger.

We organized our next outing.

"Do you think the pond is frozen?" one brother posed the question.

To which another responded, "It's gotta be! It's been cold for the past two days, for cryin' out loud."

This exchange was the signal; we were going skating.

Within minutes, a flurry swirled through the house as the five of us searched our rooms and the basement for the needed equipment. Arguments broke out, and "I found it first!" echoed in the hallways. As the youngest girl and because of my size—short and squat—there was no need for me, like the others, to scramble. I wore hand-me-downs; our house was full of them. I had so much to choose from, far more than my older brothers and sisters.

It was 1964, eighty-six years after this 650-acre piece of land was given to the city by former mayor William Wilkins. Since the land was now a cemetery and considered part of the neighborhood, we—three brothers and a sister, the tomboy—decided to invite the kids from our street. Back and forth, to their houses, we ran to ask them to come along.

Three o'clock was the agreed upon meeting time for the late afternoon skating party, when the sun was down below the horizon and the ice, turned slushy from the afternoon sun and day-skaters' blades, was frozen again.

Finally, dressed in layers of semi-dry coats, hats and scarves, toting brooms, shovels and ice skates along with extra socks, we met up with our friends walked in a pack to the pond, half a mile away. As we neared the Dallas Avenue entrance, we passed the cemetery's crematorium, and some of us walked on the opposite side of the street to distance ourselves from this building. I was afraid of this place and insisted I could see smoke rising from there sometimes when I looked out our third-floor bedroom window. I knew what went on inside that building; I knew what was in that smoke. And I wondered how anyone could burn a body.

In through the large black gate with its stone pillars that flanked the entry like Beefeater soldiers, we went, one at a time, sneaking carefully past the guard's house. From behind the pillar on the outside, we ran in, one by one, straight ahead to the first big tree. Here we hid until we thought the coast

was clear, before running down the hill, around the tombstones and to the pond below. On this day, perhaps because we heard kids playing down there and wanted to see if we knew them, we stayed on the main road a bit longer, ducking behind large stones and trees as we went. It was then that we passed Joseph Woodwell's grave, the man for whom our street was named, before heading down the hill. I thought about our street's namesake, with his large, shiny, brownstone marker that stood tall amidst the mausoleums and cedar trees, ivy and stone benches. I wondered if he was a nice man, a good man, and how he had earned this prominent place in this cemetery where some of the city's famous and important people are buried.

My attention came back to our task at hand: ice-skating, which was neither promoted nor forbidden by the cemetery guard as long as we didn't get caught breaking the rules: no sitting on or toppling tombstones, no shouting and no skating when the entrance gate was chained shut.

Our late-day skate in the Homewood Cemetery was filled with bumps and falls as we held on to one another, arm-in-arm, sending the one on the end as far as he or she could go on this fifty- by ninety-foot pond. It was often me at the end, and when it was, I fell, then cried and complained about my bruised arms or knees. After the melted ice collected on my knitted mittens and froze again, they became like stiff planks and I was unable to bend my fingers. My hands were so wet and cold that I couldn't feel the tips of my fingers anymore. This signaled that, for me, it was time to go.

Just then, and before I had time to run and hide, the guard who lived in the house at the gate's entrance drove up, stopped his police-looking car with a light perched on the side and walked up to us. Our laughter stopped. "Don't sit on the gravestones!" he shouted, though no more than twenty feet from us. He didn't need to tell us these things; we all knew the rules. I plunked down on the stone slab next to the frozen pond's edge and looked up at him, the man who was shouting, who wore a uniform and a hat that made him look like a soldier in a fairytale book. We listened to his barrage of rules and regulations and then the group of us—snow and ice covered, black silhouettes against a thick, gray sky—promised to obey.

When the security officer who had interrupted our outing finally got back into his car and drove away, I realized he sounded like our father. I begged the others to stop—I wanted to go home, I told them, but they kept on skating. I continued to sit on the stone, picking at the ice and snow, hoping and waiting for them to finish. I dug in further, and when I reached the earth below the snow, I scratched at it with a rock until I smelled the earth, now opened to the air. Mossy and dank, it reminded me of spring, which I hoped

would not be far away. Wanting more of this soil, I found a stick and dug in further, uncovering grass and stones amidst the dark, black earth. But there was nothing else—no worms or bugs that I knew I would have found if this were another time. Nothing was alive here—all life lay dormant, waiting. Suddenly, I felt a chill and stood up, leaving my patch of earth behind as I shuffled down the hill that encased the pond to the tombstone where I always changed my shoes: the Cunningham family.

With this family of three—Father John, Mother Jane and Sister Birdie—I rested, leaning back, careful not to appear to be sitting on their tombstone, to untie my skates. The Cunningham family was less prominent than Mr. Woodwell, with their short, three-named tombstone, and they would surely understand that I meant them no disrespect. I was grateful they were here. And I hoped that they might also be happy for me: a little girl, freezing cold and tired, sitting with them for these few minutes. Leaning like this, I was perhaps closer to them than any of their relatives who visited would ever be. And I was certainly closer than any passersby who used this road in between their three-person headstone and the pond, between today's chilled bodies of skaters and the dead. I leaned against Birdie, rubbing my frozen toes and pulling on my boots, wishing someone would carry me home.

After minutes of calling to them, some were finally tired and ready to leave, too. When they were back in their boots, we walked up the long, dark hill to the main road, and I don't remember ever being so happy to be on flat, dry, sturdy concrete. It was nearly dark, but the road, much higher than the hollow that cupped this small pond, glowed in the softness of the early evening's winter light. As we neared the gates, lights from the gatekeeper's house, glaring through lace curtains, came at us with such force that we had to squint our eyes to see. No need to sneak past now. We walked toward the guard's house, and I looked back down the hill where I could see the outlines of tombstones but not the pond or the figures of the persistent skaters. As we passed through the tall gates that would soon be locked shut, the sound of the boys who were not willing to give in to the cold or the dark faded, then was gone.

Finally, we were outside and walking down the hill of South Dallas Avenue, passing the crematorium, sliding on the sidewalk, slippery from not being shoveled, when I asked my sister if Joan of Arc, the saint we learned about at St. Bede Catholic Elementary School on the other side of the cemetery, had been cremated in a place like this. She explained that this saint had been burned, chained to a stake for having strong faith and refusing to give it up.

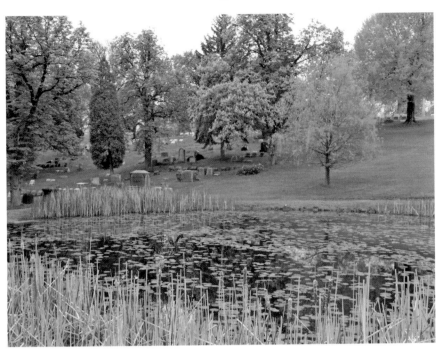

The pond, in the springtime, of the Homewood Cemetery at the base of the hill at the corner of Dallas and Forbes Avenues in Pittsburgh, Pennsylvania.

"Oh," I responded. And when Joanne offered more explanation, I became frightened and took off, running as fast as I could through the deep snow between the sidewalk and the cemetery fence. She ran after me, and when she caught up, she found me crying. I wouldn't tell her why. I didn't want her to know that I had decided, then and there, that I would never hold onto my faith if ever threatened to be chained and burned at stake.

After dinner and cleanup, I felt warm and drowsy from all our adventures. Yet, I was restless. As we gathered in the dark and quiet living room, Dad gave the "okay" to watch television, so my brothers and sisters draped themselves on the living room furniture like our clothing that still hung on the radiators. Dad, amidst the gunshots and pounding of horses' hooves that emanated from the television, sat in the corner of the room in his chair next to the good lamp, reading.

Uninterested in the program about the Wild West and wanting to talk to my mother, I lay down on the living room floor and nuzzled next to her. She preferred lying here, on this pink satin quilt in the center of our living room floor, rather than sit in a chair. Her disease made it difficult to hold her head up, kept her from walking and climbing stairs. "My legs

are useless," she would often say, then add, "but we should never give up our faith."

The soft coolness of the satin was soothing against my hot, red cheeks, and we talked. Then she read to me about faraway places and people with dreamy lives, where magical things happened. I became groggy and felt myself falling off into sleep, when my mind drifted back to Joan of Arc. I tried to stir awake again, wanting to confess my decision and plead with my mother. But it was too late; I fell into a deep sleep and was not able to ask if she thought giving up her faith might save her from the fiery torture of her disease.

"Antique" Is a Verb

Lewis Run, McKean County

By Patrick Manning

For my grandmother

THE PROFIT MARGIN

My grandparents' small lawn filled with people at 10:00 a.m., milling about with notebooks and pencils to assess the furniture, rusted Coke signs, jewelry and other antiques spread out on the yard. From where I sat on the front porch with Grandma Loretta, I watched cars slow as drivers looked for parking spaces, the town not used to this amount of traffic. It was late August, and the sun was hot. Using his baseball hat, a man fanned himself as he inspected a turn-of-the-century armoire. A woman in cut-off jean shorts and a white tank top used a battery-powered, handheld fan to keep cool. In front of the gathering crowd was the auctioneer's podium just outside Grandpa's antique shed, now emptied, its doors open like a Good Friday tabernacle.

The auctioneer looked like Santa Claus but dressed like a Texas oil man: white beard, plump, with a three-piece suit, Texas tie and Stetson hat. After meeting earlier in the morning with my grandfather—Tony Marzucco—the auctioneer insisted that Grandpa leave during the actual auction. *You'll just get nervous*, he said. *Better to let us handle it.* Reluctantly, Grandpa agreed, but not before handing Grandma a handmade ledger to keep track of how things sold. He knew how much he had paid for everything, and for most of it he hoped to double his investment. Before leaving, he snuck into the crowd, not

letting on that he was the owner. He was nervous and anxious. Everything, all of it, an entire summer's booty, was laid bare for the world to see—and buy. Or worse, not to buy. He inched into the crowd, glancing over shoulders as men and women jotted down what they wanted, how much they expected to pay and the items' details. The auctioneer, seeing him, came over, took him by the elbow and said, stroking his beard, *What you lose on the apples, you make on the bananas.* Grandpa got into his El Camino and left at about 11:30 a.m., just before the bidding began.

For me, no more than ten years old, the whole thing was a spectacle: the antiques and their collective history strewn across this front lawn, itself an antique, a relic of wiffle ball games and picnic food and immigrant dreams; the gathered crowd traveling to Lewis Run from across northwestern Pennsylvania, Johnsonburg and DuBois to the south, Bradford and Derrick City to the north, Warren to the west and Eldred to the east; the expert's assessments and the novice's judgments; everyone waiting to hold up their placards and claim their next big investment, their own piece of history.

THE HUNT

In the early morning, Grandpa starts his red El Camino, the engine loud and chugging like a train. Today's copy of the *Bradford Era* is in the passenger seat, folded open to the classifieds, each promising a garage sale circled with a blue Bic. He shifts carelessly and pulls onto Main Street, Lewis Run, without looking—knowing from experience that there will be no one on the roads this early. He drives the car from muscle memory, not sight. The speedometer climbs too high as he drives east, away from Our Mother of Perpetual Help, past Jose's bar, which his son used to own, and the post office with the flag quiet and heavy in the humid summer air. To his right, the sun hits the baseball field and the assisted living home. Years earlier, the local school—the one Grandpa's five children attended—had been demolished to build the home. As he drives by, he doesn't recall or remember the school or the how-many-years-ago of its demolition; he doesn't remember because he doesn't need to—because the space is full of memory, living and palpable.

The road turns again over the railroad tracks. On the left, Keystone Powdered Metal Plant is still quiet because the workers haven't yet arrived. The plant—newly constructed, sleek metal, white, clean—was built on the cemetery of the Hanley Brickyard, where Grandpa worked for years. The bricks made by him and others constructed town halls, homes and chimneys

Tony Marzucco's El Camino parked on Main Street, Lewis Run, circa 1990.

across Pennsylvania, across the country, but their primary triumph was Lewis Run, this small town, drawing Italian immigrants from halfway around the world to this corner of Pennsylvania easily missed from Route 219.

Opposite the plant, on the other side of the railroad tracks, the hill is gouged, a horseshoe shape cut out of the hillside like a bite from an apple. The ground is still red from the brick dust years and years after the brickyard shut down, spiraling Lewis Run's workforce toward unemployment. Before Keystone came, the ancient brickyard stood behind a chain link fence; its smokestacks, warehouses, furnaces and conveyors rusted, decayed and silent. Once it was sufficiently rotted, the new factory arrived and kept Lewis Run's logo true: *The smallest industrial borough in the world.*

It's called "The Back Way," this path out of Lewis Run down High Street toward Bradford. It's the way my grandfather drives when he starts out for a garage sale. This is the beginning of the drive, but the hunt for antiques starts earlier in the week. On Wednesday morning, Grandpa carefully peruses the *Bradford Era* in his blue recliner, looking for addresses he might recognize, parts of town to avoid, homes likely to be getting rid of treasures. At times, he's unsure of addresses, so he folds the paper and says to Grandma, *Hey Bud, where's Robroy Road?* She knows, without thinking twice. *You know where it is, Dad. Out Derrick Road, before Rew Hill.* He grumbles and circles it. *Probably won't be nothing but junk.* But he circles it all the same.

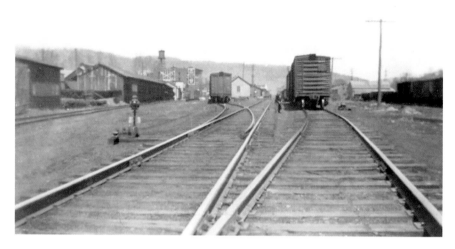

Above: Erie Railroad crossing near Lewis Run, Pennsylvania.

Below: Hanley Brickyard.

After exhausting the newspaper, he moves to the porch and sits in his secondhand leather chair; Grandma follows him and sits in her wicker rocker. He turns on the radio, always adjusted to WESB, and listens to the call-in classified program *Adline*. He turns the volume of the radio up too loud. To hear better, he closes his eyes and tilts his head. The voices on the radio are fast, each one interspersed with the announcer's invitation: "Hello, you're on Adline." Like auctioneers, the advertisers read the items they have for sale—cribs, antiques, clothes, lawn mowers. A dutiful student, Tony sits

with a pen and yellow pad, jotting down the numbers and addresses of the items he wants. If the speaker goes too fast, he says, *Bud, what's that again?* She always knows.

On this Saturday, he picks me up. Early. It's summer, and the sun is just coming up: six or seven o'clock in the morning. I'm just a child but excited. My grandfather is a mystery, a secret, an antique—full of stories about dirt roads and baseball games and small-town-dreamed-up mafia wars. From the living room, I hear his car horn. He doesn't get out of the car. My mother—his daughter—walks me to the front door, and the humid heat of early morning smacks me. I rush to the running El Camino and open the passenger seat to get in. From the front porch, my mother yells, *Be careful, Dad. Drive slow, and don't go too far.* He just waves his hand at her and spins the gravel in our driveway as he pulls the El Camino onto the road. In a flash of dust, we're gone. The car smells like hot leather and Copenhagen. There's no cup holder, so the Styrofoam spittoon is balanced on the middle seat. *You're going to have to help me lift some things.* He tells me this to explain why I'm in the car. I nod. Despite the heat, Grandpa wears a Marzucco's Construction windbreaker over his gray A-shirt; the shorts he wears are paint-splattered. On his bald head, a red Marzucco's Painting hat sits loosely. Both the windbreaker and hat are from companies his sons built in southern Florida—a place miles and decades away from our hilly home.

Even though the engine vibrates, inside the car remains quiet as we go deeper into the hill, up and up and up. The radio works, but he doesn't put it on. *Where's the first one?* The newspaper is folded on his lap, and he hands it to me to read. I read the first one that's circled. *No, not that one.* He says, turning from the road to the newspaper in my hand, *Here.* My grandfather's voice is rough, not unkind, but strong; he's developed it on railroad lines and in brickyards and barrooms. It's a practiced voice, tough and beautiful like the hills we climb in that beaten-up El Camino.

I get the address right—13 Robroy Road—and tell him the sale doesn't start until ten o'clock. *Ahh,* he mutters, *we'll just go check it out.* The ad clearly reads *No Early Birds*; I offer him this warning, and he ignores it. The garage sale is on a back road in Derrick City, a town named for the oil derricks that once forested the hills. Today, decades since the oil boom, the trees have taken back the land, but the faint smell of oil and the occasional rainbow puddle belie its history.

The first pass at the house is just a survey. He's timed this perfectly—8:00 a.m., and they're just starting to set-up. Racks of clothes—not a good sign. First rule of antiquing: when people are trying to sell used clothes, it ain't

the real thing; probably a bunch of junk. The second pass is slow. It feels like I'm a shark, circling my prey, surveying, waiting. The house is burnt red, old and set back from the road. The man and woman setting up are in their mid-fifties; they both wear blue jeans, and she has a large straw hat that bobs at the sides of her head. The woman pulls clothes out of cardboard boxes and folds them neatly. Her husband arranges some trinkets—another bad sign—on a table near the driveway. To get their attention, Grandpa puts his hand out his window and bangs on the side of his door. Surprised, they both jump and then turn toward the car. *Got any antiques?* The car hasn't stopped, but it is creeping along. Slowly, slowly. *A few. No early birds though.* My grandfather ignores this empty threat. *Any armoires?* A particularly hot item this summer. *Ain't selling anything 'til 10, friend.* He doesn't waste any more of his time on these used clothes–peddling folks. *Nothing but junk*, he says and accelerates down the road.

My embarrassment is short-lived when I see Grandpa isn't fazed in the least. He drives with his right palm open on the steering wheel and the other hand out the window. He turns up Derrick Road toward Rew, and we make a giant circle around the hilltop, climbing up, up, up and then, just as suddenly, down, down, down through Sawyer into Bradford. The roads are narrow and make sharp "S" shapes into the same valley where my grandmother grew up. My grandfather and I both know this is true. Underneath the El Camino's tires is a family tree about to sprout, an entire world history burgeoning beneath the asphalt. No one needs to say anything; you need only look out the window and know where you are.

THE SHED

At first, the shed was more of a museum than a storage space. The wood was old and gray, and it was situated at the back of my grandparents' small yard. My cousin Matt, brother Shawn and I hid from our parents behind the shed and used the privacy to practice curse words. Old farm equipment was nailed to the outside walls. Inside, the floor was constructed of concrete blocks and covered over with outdoor brown carpeting. At first, the antiques were set up along the shed's interior walls: wood cabinets and tables in the back, smaller items toward the front. In the center, Grandpa set up his own chair, a place for him to sit and look at the history he'd collected and hoped to sell. But in the boom years, the antiques filled the entire shed; there was no place for a chair. Just trying to get through was difficult and exciting, a time machine of wood and metal and other people's memories.

Anthony Marzucco's antique shed, 2011.

Some families have heirlooms, items that exist across generations, trunks or jewels that made the trip across the ocean, through Ellis Island, on railroads and buggies to small towns throughout the country. Some families keep these things in special places, wrapped in handkerchiefs or displayed in china cabinets. Some families have tables or dressers or cradles that a patriarch somewhere along the way hewed out of oak or pine. In our family, though, we have collections of other people's stuff: a hodgepodge history of bits picked up across the small towns of Western Pennsylvania. In my living room in Michigan, I have an old reproduction of da Vinci's *Last Supper*; an end table with an intricate rose design and clawed feet, a barely held together record player stand and album storage cabinet and a manila envelope of a stranger's letters to his parents during World War II. All of these came from some garage sale my grandfather went to, somewhere in the valleys or on the hills around Lewis Run.

The shed was locked with a padlock, but the key was hung on a hook next to the shed door. Like an attic, or a photo album, each time the door was opened, the space was familiar but new: a rusted Kendall motor oil sign hearkening to nearby Bradford's refining days; rocking chairs from estate sales; costume jewelry from the pawn shop; cabinets; turn-of-the-century fishing tackle; mirrors; school desks pulled out of neighborhood schoolhouses when the district consolidated; 33 1/3 rpm records with the gramophone, although

the cone had been missing for years; blue glass bottles lining the walls; lamps; children's wooden Hasbro toys manufactured in Kane; metal lunch boxes; shelves and shelves of tin toy trucks. One of his prized possessions he kept on the deck: a judge's chair from the courthouse in Smethport, the county seat. It was torn and faded, the stuffing coming out from the rips in the leather. To repair it, my grandfather used duct tape and a garbage bag. Next to the chair, he kept a bright red megaphone; he used it to yell at his friends and neighbors from his seat. *Hey, oh!* And they'd all just wave. *Hi, Tony*, they'd say.

SHOW AND TELL

In sixth grade, I had a unique show-and-tell assignment: find an ambiguous object, come up with two other possible uses for it and see if the class could determine which one of the three options was correct. That night, my parents took my brothers and me to my grandparents' house. It was late in the school year—May—but early in the garage sale season, so the shed was almost empty, my grandparents having only recently returned from their winter in Florida. Still, though, there were a lot of small items—things Grandpa had picked up on their drive from Florida, stopping at flea markets and yard sales along the way, or leftovers from last year that hadn't yet sold. Moving through wasn't easy. I maneuvered in the maze of cabinets and chairs, back, back, back to a small folding table. There, I found something I couldn't define: it looked like scissors, sort of, but the blades were rounded instead of sharp. The rest of the family was on the deck, and I took the mystery item up to them.

What's this? I asked, gripping the object at its charred, wooden handle, the rusty blades pointed down. Grandpa swiveled his chair, the garbage bag crackling underneath him. *Give it here.* I handed it to him, and he turned it over. *It's a lady's curling iron. You'd stick this piece in a fire or stove 'til it got hot*—he pantomimed this, thrusting the metal prongs forward into an imagined furnace—*then take it out and curl your hair. Might have another one in the fire while you're using this one.* And he put the curler up to his bald head and twisted his wrist back and forth.

That Monday, I took my curling iron into Derrick City Elementary, a small, brick schoolhouse that would be shut down by the district in a year. Everyone in the class brought in their treasures, mostly rusted and old items; some new, state-of-the-art gadgets. The game was to stump people. Cassandra brought in an automatic card shuffler that took a while to figure out; Mitchell had a Tamagatchi pet, a little electronic game that was just then gaining in popularity. When it was my turn, I displayed the item up and

down the aisles of desks and then said, certain I'd stump even Mrs. Reitler: *Is it a pair of scissors that are dull because they're so old or an old curling iron that women used in like the 1800s? Or is it cooking tongs used for campfires?* The deliberation began, and almost immediately the class was in agreement that the little metal thing I was holding was indeed a curling iron. Defeated, I said *yes* and took my seat to let Jamie have her chance to stump us all.

Antiques can play tricks, leaving the impression that change has come too quickly, that our history has been destroyed or overwritten by the drive forward. Rusted and cordless, it was impossible for me to see that the curling iron from the nineteenth century was missing only the cord of my mother's own twentieth-century one. Layers and layers of paint and rust might suggest, at first glance, misuse or disuse, a forgotten relic of history, making it impossible to recognize that the new depends on the old. Rust and new paint jobs don't erase but instead serve as maps, tracing back to home. Our antique past—ancient factories or demolished schools or oil fields—remains just below the surface, bubbling underneath our car wheels; not a noun, an object, a thing to have, but a verb, a doing, an action of remembering. Who we are always dependent on who and what has come before, people and places built by Hanley bricks and the Alleghenies.

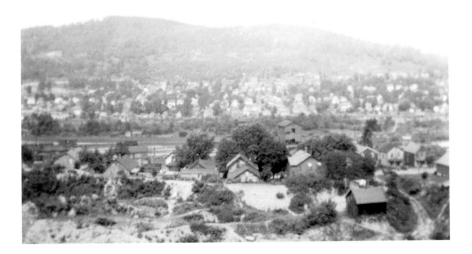

Lewis Run, Pennsylvania—a panoramic view.

Wood Street Memories

Erie

By Mary LeDonne Cassidy

Our house on Wood Street in Erie provided me with a peaceful contentment that warmed up from the center of my body. During the summer, when bedtime was before sunset, I would lie in bed and hear my parents talking in the enormous garden they planted between our house and the neighbors' and feel secure hearing their hushed voices, the quiet murmur of love at the end of the day.

My first best friend lived two doors down from us on Wood Street. We were two weeks apart in age, and in my earliest memories, she had been there forever. My mother said that when she and Brenda's mother compared babies, Brenda's mother said of me, "Why, she's beautiful! But my Brenda is smart!" The rivalry continued on between the mothers. I envied Brenda her blond, Shirley Temple curls. It took me a long time to get past my blonde envy. We lived on a block with lots of kids; Brenda and I each had older brothers, but the oldest kids on the block lived up the street in a family of eight that kept growing. Some of the time we would all play together, though a lot of the time it was just Brenda and me. We were free to roam up and down the street, picking flowers that were mostly weeds growing by the side of the road or in still-empty lots: Indian paintbrushes, bachelor buttons, dandelions, daisies and buttercups. Best of all were the Queen Anne's lace, with either a spot of black in the middle, like the embroidery ring Queen Anne used, or red like the blood from when she pricked her finger, thus sealing the fate of her daughter, Sleeping Beauty.

One of our great treats was when we got to go to the "candy store," which is how we thought of it, to buy cigarettes for our neighbor, Katie. She gave us fifty cents and told us we could buy candy with the change—penny candies like root beer barrels, jaw breakers, candy that looked like bacon and eggs and, my favorite, malted milk balls, two for a penny. Katie and Al didn't have children, but they treated us neighborhood kids like adults. Katie served us tea in delicate, bone china cups.

The ooze park, what we called the zoo, was a little farther afield, so we could only go there with an adult. My mother took us there when our brothers were in school; we looked at the animals as long as we wanted, which often wasn't long, as the smell in the zoo was an overwhelming mixture of restless caged animal and excrement. One time, she decided to walk us over there after lunch. In those days, in that place, no one locked the doors, and when we returned, there was a note from one of Mom's friends chastising her for leaving dirty dishes in the sink. I don't know if she was offended, but she told that story many times, laughing about the foolishness of folks.

Even farther afield was the peninsula, Presque Isle, our beautiful seven miles of beaches on Lake Erie. This was before the worst of the pollution, and the lake was our mecca. On hot summer days, my mother, or any other

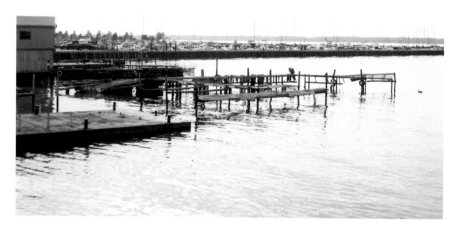

Pier at Presque Isle. *Photo courtesy of Andrew Steinmetz.*

mother on the block who had access that day to a station wagon, loaded as many kids as could fit into the back, and we rode out for a day of sun and sand. No seat belts—Brenda and I stretched out on the flat far back.

One time, Brenda's mom took us to the movies downtown; we were to call her to get a ride home. When we got out in the late afternoon, we couldn't find a phone booth. As a seven-year-old, I decided we could walk home. We were on State Street, one block over was Peach Street and that led right to Wood Street, two or so miles away. It was still daylight, but we had to pass a number of bars, and Brenda was unsure about the plan. That's when I came up with the brilliant idea that whenever we felt nervous about people on the sidewalk, we would point ahead of us, say, "Oh, there he is, there's Uncle!" and set off running. We did that two or three times. I doubt that we were great actresses, but we did reach home without incident. My mother was furious; I don't think she ever believed that I was the instigator in this little event because I was her good girl. She blamed Brenda's mom.

That wasn't the only time there was friction between them. Both our mothers sewed, so they both kept "rag bags" of old clothes, fabric left over from projects and other delightful items. One time at Brenda's, we dressed ourselves up in the leftover finery; an old crinoline became a strapless dress for a girl too young to have anything to hold it up and bits of lace became veils. Her mother let us put on makeup, too, which we smeared on rather heavy-handedly. Brenda's mom took pictures of us; unfortunately, we both were at the losing baby teeth stage, and when the pictures appeared in the paper, my mother, who really was mostly an upbeat, positive person, was angry—first that my picture would be in the paper without her say-so, and second, because it was not an attractive photo.

It was while we lived on Wood Street that I learned one of my most important lessons. Brenda and I had been playing way up the block at a home we didn't go to that often, and I came home with the most amazing thing I had ever seen: a gray and white plastic cow, about four inches long, with jointed legs that meant that when I put it on an angled board, it would walk by itself. I could not get over it. But when my mother asked me where I got it, I ran into trouble. I told her where, and she asked if they had given it to me. I had to say, "No, I just took it." I had to take the cow back, admit what I had done and apologize. The shame of that wasn't the worst of it; the worst was having to give it back.

Brenda taught me that when something is told in secret, and I'm told to keep it a secret, that means I shouldn't tell it to anyone, not even my best friend. My older brother was rather small and wiry. One day when he was racing down the marble steps at a memorial in Washington, D.C., he

tripped; however, he simply turned the trip into a somersault and kept right on going. This physical ability inspired my mother to sign him up for dance lessons at the YMCA. Not ballroom dancing, but modern dance. So, of course, I told Brenda while we sat on the swing set in the backyard. The next day, all the kids knew, and Pete dropped the lessons.

We spent a lot of time on that swing set. Brenda had a good voice and could carry a tune, a skill that skipped my family. We were so bad that when unsuspecting visitors sat in front of us at church, they moved before the sermon. We might not be able to sing, but we did it loudly! Brenda sang songs her mother taught her or that she heard on the radio, and I listened, enthralled and envious. One of the songs that puzzled me, though, was about a cinnamon that was supposed to run. I knew the story of the gingerbread man, so I conflated the two. It wasn't until I was grown that I recognized the spiritual where the sinner man keeps trying to run from an angry and punishing God. I like my interpretation better.

<p style="text-align:center">≈◆═</p>

When I was eight years old, my mother's father had already moved in with us, and my father's mother wanted to do the same. Our house was too small for even one in-law; my brother had to share his room with Grandpa. So my father found us a new, much bigger house on the outskirts of town. My mother hadn't wanted to move at all, but Dad knew what he was doing when he found the house on Elmwood Avenue. It was on an acre and a half of land, was three stories high and was beautiful—in need of a lot of work, but beautiful all the same. I remember sitting at one end of the living room, which ran the length of the house, and looking at the other end so very far away. I couldn't believe we were really going to live there. The day of the move, instead of us coming home for lunch and Mom reading to us, Dad took us out to eat lunch at the diner. I was allowed to order a peanut butter and jelly sandwich on white bread and a Coca Cola, things we weren't allowed at home.

After we moved, Brenda and I stopped being best friends, through lack of propinquity. We still went to the same schools, but our friendship dissolved. We had had fights when we were together—I threw my shoe at her once, an act of violence that surprises me to this day—but nothing ever separated us until the distance of a single mile. Our closeness was a product of time and space. Since then, I have moved many times, made friends and lost them and stayed loyal to another Erie friend through it all, but Brenda, my first, will never be forgotten.

Litter Pledge— Seeking Eden

Lucinda

By Barbara George

Thank God men cannot fly, and lay waste the sky as well as the earth.
—*Henry David Thoreau*

Daily prayers are delivered on the lips of breaking waves, the whisperings of grasses, the shimmering of leaves.
—*Terry Tempest Williams*

We opened fifth grade science books on cue; the day's lesson was on pollution. Behind us, the ancient radiator hissed and spit. Our books were new, in contrast to the religious catechisms, which had been given to us in the first grade. Though it was the early 1980s, those still featured '50s-era illustrations of pious, golden-haired children, hands crossed in solemnity with a rosary entwined. The accompanying text told us, among other things, that God had created the world and was omnipotent and benevolent, which we repeated back to Sister when it was our turn to do so. In that same class, Sister swept through the aisles in her black habit, showing us our first relic—a bone of her patron saint no larger than a pinhead mounted on heavy card stock.

Our new health books showed pictures of Lake Erie, the text explaining that Lake Erie was a good example of pollution. The colored picture of

garbage bobbing in the waves underscored the point. The text and images moved to Rachel Carson and her writings about the problematic nature of DDT. Another picture of broken eggs due to the fragile shells illustrated the disastrous effects; the confused eagle parent looking on, distraught. The class in rural Catholic school was in lecture format. To even answer a question asked by a teacher, we must raise our hand, stand up when called, deliver our answer and then sit down. Had we been allowed to discuss Lake Erie in class that day, I would have volunteered that we went to Lake Erie every summer. And it was clean now. I was young and confident that Western Pennsylvania was the most beautiful place in the world.

That day, all students received a small plastic bag: among the papers that offered helpful hints on how to stop pollution was a certificate pledge and a small green and white sticker declaring the owner's intent never to litter. After school, two of my brothers and I began the walk the mile from school to home, our backpacks late in the year looking worse for wear. The fragile Western Pennsylvania spring provided beautiful weather for walking rather than riding the bus. The journey began with us breaking through the pines below the church hall, where a friend and I would later find discarded holy water fonts—the paint peeling off of the plaster angels that had earnestly held bowls of holy water in the back of the church for so many years. It troubled us to see the angels lying askew on the forest floor, staring up into the pines just as piously as they had while in the church. A pastor who clearly had little imagination had thrown them there. He replaced them in the church with modern dark brown wooden box fonts, undoubtedly easier to clean. Below the pines, we followed the sloping field to our road, walking right past the kitchen window of the Snyders' farmhouse. Walking on other people's property was par for the course in Lucinda, though when our cousins visited, they balked at striding across someone else's backyard.

After turning onto our road, we could look back to see the St. Joseph's spire above us. The pleasing patterns of red brick reigned gracefully on the top of a hill. The hardworking and proud German settlers had offered time and resources to create this tribute to what they remembered from the southern German countryside. The lines of the church itself, the stained glass, the statuary, were the only art I ever saw and sowed the seeds for possibilities of other worlds I would later explore.

On the other side of the road, Griebel's Farm sprawled comfortably on another rise. Our road, Sunset Drive, followed the valley between. Fields and woods stretched along—hiding the strip jobs that dotted the lands behind.

We saw farms everywhere, but no one in my tiny grade—there were eleven of us—grew up on one. We were one generation removed from the farm, though our class was still being raised with a farmer's ethic of working hard and contributing to community.

As we continued down the road, the church appeared through the branches of the trees. It certainly was the hub of Lucinda, and it was impossible to escape seeing it for miles around. At that age, I wasn't sure what the few families who were not church members did. It was nearly all of the social fabric: school, church dinners in the social hall, bingo and dances, though those fizzled out sometime in the 1980s and '90s.

The crowning activity was the Fourth of July Festival, which, in true Catholic tradition, centered on gambling in its various forms, with wheels of chance ticking, awarding the young with cheap, colorful prizes. I distinctly recall a general favorite: a bird that warbled when we filled it with water and blew into it. The true wealth lay in the handmade quilt booth, the products of which had kept the parish women busy during the winter. My siblings and I were scandalized when the quilting was put in at our house. We listened to the chat or gossip as the women smoked cigarettes while quilt patterns traveled beneath their fingers in curves and scrolls. There was also the booth where one could win a twenty-dollar bill and the baked goods booth full of tidily saran-wrapped homemade brownies, cakes and pies.

Everyone in the parish worked on the Fourth. Volunteering began on days leading up to the event, and there was at first a clear gender assignment. Women handmade rows of egg noodles on the long tables in the hall, which were dried in the rectory attic. The men rolled up in pickup trucks the day before and assembled the booths. On the day of the Fourth, we worked the morning or afternoon session. The proceeds went to the church and the school, and we had history to uphold. It was rumored that buses of diners traveled all the way from Erie and Pittsburgh to eat at the dinners.

For years, I was an incompetent water girl at the Fourth of July dinner, serving water to the rows of diners who sat at white paper–covered tables that stretched the width of the hall. Diners ate family style after picking up their slices of homemade pie on the way in. In high school, when I was older and more accomplished, I worked as a waitress and brought out the food: platters of ham and chicken that disappeared as they were passed down the table. Bowls of potatoes and corn and crocks of gravy were similarly consumed. We rushed back to the window separating the dining room from the kitchen to get more. Behind the window, women and men alike worked to fill the bowls. It smelled wonderful. Cooked potatoes were thrown into

a ricer and mashed, and corn was ladled. The steam rose up when the roasters were opened and chicken dished out. Each family contributed a cooked chicken for the meal. Dishwashers kept pace; the magical Hobart dishwasher introduced in the late '80s alleviated some work. As workers, we ate our dinners in the red brick rectory garage. Our cousins, who came from exotic places like Erie and D.C., did not envy our working day but did envy the "free" dinner we got to eat in the garage.

Bingo raged in the basement of the hall, stocked with the serious and sturdy sort of women who knew their God-given rights. Later, when in college, we thought it would be fun to volunteer for the Fourth again. My brother was assigned to sell bingo cards and asked a group of women to extinguish their cigarettes in deference to the No Smoking signs placed in the hall basement a couple of years before. These ladies made short work of him and his outlandish presumptions and continued to puff away. No surprise that they were all related to our surly bus driver, who, when we were growing up, hit the gas if he saw us running down the driveway to catch the bus. It brought home the unspoken understanding of Lucinda: one followed the rules, whatever they may be, and suffered the consequences for loitering, being late or changing the old rules—even if the new ones were clearly posted.

That spring day after learning about the polluted Lake Erie, we continued along the road. Those who inhabited Sunset Drive were pious folk, and most were only a generation off the farm. The houses could have fit into a suburban park, but the fields or woods provided the backdrop. Lucinda, if not particularly prosperous, was for the most part tidy and comfortable. When we drove out to other towns, often only a few miles away, or to larger areas like Oil City, Titusville or Pittsburgh, we gaped at the abandoned mansions, millhouses, trailers, coal tipples and steel factories ubiquitous in Western Pennsylvania—environmental degradation in full frontal glory. A half-mile down the road, we stopped at the bridge. We always paused here to throw a couple of stones. To the right, a dirt road disappeared into the woods and strip jobs; a rusted sign reading "Rifle Range" revealed the source of the gunshots we heard with regularity.

Dad, a chemistry teacher at Clarion Area High School, didn't hunt or shoot, which made him an anomaly for a male. He preferred to read, travel and commit himself to church, community and school events. Beyond the range were the strip jobs, which abounded; each had its own features. This strip job was part of what we called the "High Wall," so called because the stripping had resulted in a nearly vertical wall, which we slid down in the

winter. Nearby was also the bobsled trail, a twisting ravine gouged out of the earth. Both were conveniently denuded of foliage for a smooth ride. In the summer, these lands were arid and coursed through with red ditches due to the acid mine drainage seeping to the surface. Each year, nature covered more, but the lands that had not been returned to the original condition after stripping was eerie, and even as a young girl, I knew it was unnatural.

At the bridge, a ditch gushed with red water drained from the strip jobs and deposited it into Steppe Creek, which had been there long before the strip mining. We put down our backpacks and dropped leaves in on one side of the bridge, then ran to the other side to see them float by with a feeling of satisfaction that the water was indeed flowing as it should. The leaves disappeared into a forest glade. There were no fish in Steppe Creek. It was here on that spring afternoon, with a weak but brave sun, that we recited the litter oath, swearing to care for the earth by picking up trash. My brother repeated his vow. I stated mine. Church had given us much experience with pacts.

The Artist's Lesson

Pittsburgh

By Amanda Lynch Morris

THE ARTIST

"Teach me how to paint?" I asked my dad, who was working at his slanted wooden worktable on a Mr. Yuk design for the Pittsburgh Poison Center. The almost floor-to-ceiling windows stretched the length of the wall, giving us a third-story bird's-eye view of our lush square backyard in the 'burbs of the 'burgh, as well as the backyards of our neighbors to the right, left and directly behind us. Our crabapple tree hung heavy with red, sour fruit; the grass was dark green and thirsty; the roses climbed the length and breadth of the garage wall weighed down with broad pink flowers and humming bees. The neighbor kids played and screamed and laughed in the yard next door to the left. To the right, our sedate and low-key professor neighbors worked silently in their garden, laden with vegetables and herbs. From somewhere in the neighborhood, the scent of a charcoal grill just firing up wafted through the open window, filling the studio with the promise of a burger and dog dinner.

SUMMER 1979

Always eager to learn new artistic skills, having "mastered" by the age of nine the fine nuances of musical theater performance, ballet, tap, piano and singing in my culturally oriented city, I wanted my dad to show me how to do what he had spent a lifetime learning. Faster was always better for

me. Spending slow, methodical moments meticulously learning a skill was laborious, boring and, well, hard. Hard and boring were the antithesis of my fun-loving and convenience-coveting nature at that age. I sat on the edge of the tweedy green sofa against the studio's one wall, eagerly awaiting the artist's generous offer to share his hard-won knowledge with his daughter.

"No." He turned his head and looked at me, putting his sketching pencil down in the groove at the base of the tabletop.

I pouted and whined, "But why?"

"If I teach you how to paint, you'll paint like me. And I want you to paint like you."

It wouldn't be until I was much older that this lesson's meaning started to resonate with me. At the time, I was resentful that my dad wouldn't share his secrets. When I watched him work—sketching or painting with watercolors—I witnessed magic. Beautiful images came together and sprang to life on thick paper and canvas; shadows, colors and stark lines merging and combining into farmhouses, wooden sleighs, city porches with elderly couples rocking in chairs, Pittsburgh's skyline growing up from all different angles, Kaufmann's clock, the practical frame hillside homes of

Spring Hill.

the Southside slopes under a moody sky, the muted red and gray tones of St. Patrick's Church in the heart of the Strip, Gimbels' windows delighting Christmas shoppers in the snow and Market Square in the warm light of the sun on a rare cloudless day.

These images infused my childhood with a sense of the place called Pittsburgh; I learned to view the city through my father's artistic lens, a tangible response that now plays out in my photographs of the city. As a child, I wanted that magic without wanting to work for it. I didn't know how the artist created these pictures from nothing more than a pencil, a brush, some paint, lines and his imagination as he observed the place where both he and his working-class Irish father grew up, but I was certain I could create these pictures, too, if only he would show me how.

At the time, however, I simply complained that it wasn't fair that he wouldn't show me how to paint, not understanding that he wanted me to learn how to see a barn, a city street, an abandoned warehouse, a back porch, a woman crossing the street, a crowd of Strip District shoppers through my own lens, developed over time, with dedicated practice and through experience. That my imaginative vision of the world had inherent worth and value on its own, without being given the guiding hand of a true master leading the way—this lesson is something I've grown to value and appreciate as a writer and photographer. And some day I am sure I will put pencil and brush to thick paper and canvas and put the basic shapes to work for me.

"I won't show you how to paint, Amanda, but come over here and let me show you something."

I got up and went to my dad, snuggling against his arm and not hiding my disappointment as he pulled out a blank sheet of paper and a pencil. He adjusted the light so that it shined onto the paper, and he started to draw.

"This is a cylinder." As he spoke, his pencil deftly created what looked like a three-dimensional piece of pipe.

"This is a cube." The artist worked methodically, effortlessly rendering the simplest shapes with lines and shading by the simplest of tools, a pencil: cylinder, cube, rectangle, triangle, circle, oval.

He handed me the sheet, saying, "These are the basic shapes that form the foundation of everything you would ever want to draw. Learn these. Practice with these. Then you will be able to draw anything. And *then* you can learn how to paint. First things first."

Frustration flooded my young, greedy mind. I wanted his skill, and I wanted it now. Practice drawing boring shapes? But I wanted to create skylines and horses running through fields and crowds of Christmas shoppers

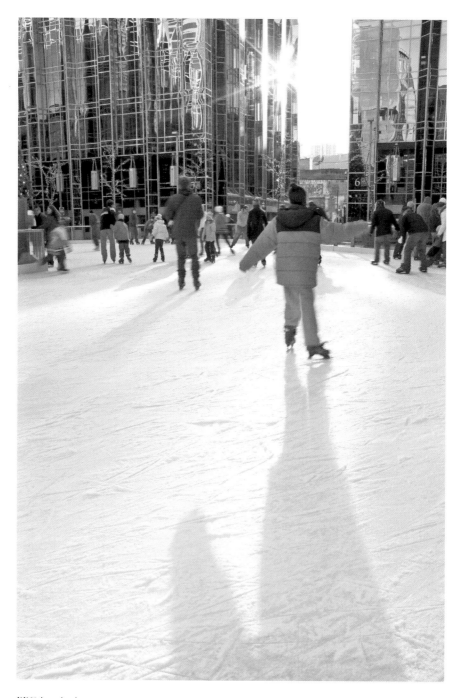

PPG ice-skating.

Father/daughter reflection.

in the snow! I think I might have put in a few minutes of effort before quickly realizing this simple skill would take awhile to master. Time better spent playing, I was sure.

Understanding the value of practicing and learning over time was something an active and precocious nine-year-old just couldn't grasp, but it is a lesson I now rely on not only as a writer and photographer but also as a professor of composition and rhetoric in a university setting. I find myself encouraging my students to practice basic skills upon which they can build more advanced concepts. To revise and try again when they fail, to not give up and keep at it in order to become better, more skilled and more confident. The artist taught me well to dream practically in a place known for its no-nonsense nature and strong work ethic.

Chopsticks

Wolf's Corners

By Jules Alder

Something died in me the day I heard that the Amish man who ran a wood shop across from our old house had bought our Schiller player piano and chopped it into firewood. *My piano*, I should say; had its practically marbled coating been etched from lid to pedals with my elfish, bespectacled likeness, the Schiller could not have been more mine. Our grandma, Dad's clannish, Irish mother, gifted us with it after Mom discovered I had *the ear*. Lessons followed; resistance to and eventual rejection of the stipulation that I must learn to read the notes rather than letting the sound guide my fingers. Later, after my parents separated and retreated to corners, neither was willing to take care of the mounting mortgage payments. We lost our first and last home to the sheriff's sale, and I lost my first instrument and friend in northeastern Pennsylvania to a few nights' cooking fires, well over a century after the invention of the electric stove.

Owning a house had been no short work. My father was a navy man. My earliest years witnessed us moving from Maine to Spain and back again, with a brief sojourn outside of Philly, before settling in the small lumber town he'd grown up in at the base of the Allegheny National Forest. Even then, we lived in rentals for years before finally trekking out into the countryside to live among the farmers, Amish and "English," who would be too busy growing the grains for their home-baked bread to bother us. The summer before, a neighbor shot my German shepherd/Doberman mutt, Sammy, and left her lying in the road, her only crime getting loose and venturing into neighboring lawns.

We were always going to be different, no matter what. We had seen too much of the world; we knew and associated with too many faceless others who came from places too foreign, from out of state. My father's and mother's families rarely mingled and, like townspeople and tourists, were eventually expected to remain as polite strangers, waving from a prescribed distance. The stoic acceptance of life's brutalities that I found among my forest-raised cousins contrasted so profoundly with my sense of the world that I began to point out that I hailed from Maine; the practice had become first nature by the time I was eleven or twelve. We had been living in our house in Wolf's Corners for a few years by then, and I was a creature of habitual reality escape—first absorbed by one of my mother's many books and then lured back into the outdoors to race in fields, explore the woods and streams, play country games like "Ghost in the Graveyard" with my brothers and the neighbors and, of course, climb our largesse of trees. I led other small, separatist rebellions as well, such as insisting on saying *soda* instead of *pop* and always pronouncing *the* like *thee*, despite funny looks.

But for the Schiller and all that it symbolized, I'm unsure I would've seen a connection between my immediate family and the kin it was so important to Dad to be near. She was a beauty of a player piano— dark, with a burnished underbelly on the hinged lid above the keys. We had rolls of music—mostly ragtime by Scott Joplin—and a switch in the back shifted the strings to transform the keyboard into a harpsichord, though I favored the sweeter, deeper sound of the strings. Her place in our dining room near the west-facing sliding glass doors to a deep backyard, I composed by and played to the sunset evenings. Sometimes, she was a handy savior in a pinch. When Larry Dale came back from Florida to visit after a years-long absence—his once-bushy red hair having taken a more disheveled, auburn allure and his frame lengthened out—I didn't know what to do with my body around him, and so I sat at the piano and tickled out my most rehearsed piece as though I'd written it for him.

Occasionally, Grandma would break one of the long silences that usually dangled between us in proximity, coughing over her diet soda, to ask me if I still played her old upright. *Oh, yes,* I always replied, always a little shocked she didn't know. In retrospect, it made sense for her to ask. Nearly all the men among my father's people play something, usually a guitar, but occasionally the fiddle or the drums. Family reunions invariably found all the men who play rotating in and out of the fray, with the occasional woman singing. Mom played guitar and sang—but seldom in public, nor anywhere the extended family could ever hear or see.

One day, I sat at the piano too long. None of the chords I tried seemed to fit the mood. Alone in the house, the tenuous, gray winter light on the motley carpeting had put me in a trance, and I had forgotten that a piano is not a table or a couch or an armchair or a wall. It had lost all of its musical properties for me and ceased to be an instrument. After a while, I returned to my senses and decided to take advantage of the ice outside. Enamored of the girls who, at my age, could do anything to music—Nadia Comaneci, Kristi Yamaguchi—imitating them invoked a simple magic. As with Yamaguchi's triple Lutz, I couldn't necessarily reproduce on the keys the complicated notes soaring through my mind when I took to the ice, but they released me from the doldrums of trying to find a note I could hit that would sound right. The raw physicality unboxed me. My imagination lofted above the clouds of Mount Olympus.

The cold, swift air against my hair and face would be exactly what I needed. A lake up the road always provided a place to skate, but the local municipality only let it be cleared of snow if the ice was stout enough to hold a small John Deere bulldozer. Otherwise, they didn't want any skating. I had hiked to Lake Lucy twice that week, past the farms clustered around the sawmill and the trailer park and the small, fenced-in jumble of electrical transformers the powers-that-be had put up between the naturally formed lake and the homely pond beside it. We had it from some of the house-dwelling neighbors that the pond was really a receptacle for overflow from the trailer park septic system, which seemed odd since the lake had so many colorful signs directing traffic to it as a mini vacation spot for the whole family. In summer, it sported a miniature zoo composed mostly of catchable birds that the water attracted, and in the back, adjacent a small diner with a jukebox and a billiards table, was one of the world's tiniest and most dangerous mechanical roller coasters. This winter, the zoo cages were empty of all but droppings and down, and the quickly ending leg holes in the stiff snow skirting the shoreline signified an uncertainty about the ice.

Our driveway, though, was awash with firm ice, and without the family car in its usual spot in front of the double garage, it was a spacious enough one. I laced my skates and started cutting figures between the end of the concrete and the unidentified evergreen that looked a lot like a cypress tree at the far side of the garage. I was able to get some real momentum within the square space, but the rocks poking up through the ice proved too problematic. After a couple of nose dives when my blade came to a squeaky stop on protruding gravel, I decided to try the small stream only yards away from and parallel to the driveway instead. By this time, I

had attracted the attention of the neighbor boy closest to my age, Danny. We had made out in the woods on his parents' property the previous summer, and things between us weren't as simple as they once had been. He followed me as I toe-picked gingerly through the thin, ice-encrusted snow with my skates from the driveway to the part in the stream where the culvert redeposited the water. There, it pooled in a stout heart shape within a slight dam of rocks before trickling onward, through our acre of woods and into the Amish dairy pasture on the other side of our fence. It had but the lightest dusting of snow. In no time, I was practicing spins, finding and testing my center of gravity. There were the faintest strains of a lilting sort of music, like an unexpected serenade, as the water trickled through the culvert nearly by the drop and under my trusty ice.

Danny sauntered off, appearing to have seen enough. For the moment, I was left alone in the dim of the woods and the unlit Fond Memories Club, a one room clubhouse whose paint-peeling shadow we had to traipse through to get to the "spring," a reservoir overflow pipe that spilled fresh water into a little tributary that commingled with the stream on our property one hundred feet from where I was skating. The algae on the pipe grew greener and thicker each year that we lived on the Corners, but that only seemed to make the water taste sweeter somehow. At the same moment I was landing a necessarily short jump, Danny returned with a pickaxe. He sunk it into the edge of the ice nearest the rusted rim of the culvert as I stopped, angry and without speech. He sunk it again and again and again, making a small wheel-sized hole in the ice, grinning while he worked the axe. I had to pull myself out of the stream with the help of some branches and walked back through the yard, less mindful of my skates. That wasn't the first time something I found exciting had reaped destruction at the hands of a boy.

From the porch, I spied a frozen, oblong mud puddle across the way, where the dirt borough road to Newmansville, past the old Herschberger Farm, met our paved state one. With Danny still occupied releasing all of the ice from its oppression of the dam, I crossed the road to investigate. The puddle was just wide and long enough to practice single jumps and landings. Straight away, I began. Moments into my routine, the rest of Danny's brood crept up. They kept to the other side of the road, only looking at me out of the corners of their eyes, skittish but ever curious. Not long ago, their entire family had ventured over on Christmas and invited themselves into the living room on the pretense that smoke was coming out of the front of our porch. The "smoke" was nothing more than the cycle of condensation and evaporation metal vents go through in cold weather. Dad left the room

"to get more coffee," leaving Mom to cope with our unwelcome guests. This intrusiveness was, after all, part of why we no longer lived in town. My parents couldn't have been more put out if the neighbors had laid road kill under the tree in the middle of Christmas morning.

It's easy to get lost in reverie when practicing high-faluting ice jumps on a frozen-over mud puddle. This was before the Amish man, the one who would later buy my piano for a pittance and hew it into tinder, bought the lot directly across from us. At the time, it was a somewhat open lot with an unoccupied red and white trailer. I could see to the crests of all the hills from our corner of the valley. I could see the vehicles that would inevitably round our bend well before they could see me. The next one—the only one that passed while I whirled and twirled in splendor over my newfound ice— belonged to Mr. Haracy, my health teacher and gym coach. He waved at me, and I waved back, and all was right with the world. Next Monday's health class got the whole story of how Jo had glowed while skating on a frozen-over mud puddle, punctuated by Mr. Haracy's sixth grade sense of animated, physical humor.

Nearly four years would pass from that day to the night my mother decided we were leaving the Corners for good and absconded with us to a farmhouse on the other side of Fryburg, near a different sawmill. Sometime during that year of respite from the fallout of my parents' divorce, I heard all about the house and its contents going to the sheriff's sale and recollected what had been left behind: diaries, schoolbooks I had meant to keep forever in some sort of imaginary vault, old photos. Many more years would pass before I took a run at the old property, to investigate and see how it had changed or to gauge how much I had changed. By then, Danny had grown up and gotten married and had bought our old house on the Corners and moved in, right across the street from his lifelong home. The house itself looked pretty much the same from the outside, but the garage had been completely renovated into a larger, truer double, roomy enough for a "monster" truck. My old friend, the unidentified evergreen, the one that may or may not have been a cypress, had lost its life to four-wheel drive. Not wanting to disturb the new homeowners, I parked up the road a bit, at the old auction house, and approached the place through the woods, around the back of the Fond Memories Club. It was summer, and the cows were munching in the field, their insistent lowing carrying throughout the tiny valley. The woods hadn't changed much; the old birch stand still stood among a network of wild grapevine. Remains of old log bridges my brothers and I had engineered poked up through the stream. I was amazed by how

small everything seemed. These woods had been a fortress once; now, they were little more than a veneer, ground cover between two properties. For the longest time, I sat on the sturdiest of the old vine, the *S*-shaped part I had once almost successfully turned into a hammock before plunking into the stream. I watched and listened to the insects buzz around. There are always a lot of flies where there are cows. I watched the cumulus clouds move across the ceiling of the valley. I watched the cars pass the house, unaware of how much had changed hands. I sat and listened for the faintest strains of music, even one hammer on a string, in vain.

The Bumpiest Roads Are in Pennsylvania

Clarion

By Jennifer Hetrick

O f all the slurred last words I can remember my mother using the remaining efforts of her body to voice, the sentence that slithered under my ribcage and still taps is this: *I wish you weren't so far away at college, Jenny.*

———◆———

My brother Scott drove five hours one way across Pennsylvania to pick me up at college so I could be home to speak at a deposition in Norristown for a car accident dating back to when I was eighteen years old. My then-beater Chevy Corsica, with its black exterior, chipped spots filled in with matching nail polish from CVS and blue back bumper, had an ambulance chaser slam into it at a speed well beyond the road's limit.

In his white Nissan Sentra with more than 260,000 miles built into its history, Scott zipped up Interstate 80 from the suburbs of Philadelphia to what my poetry professor titled "the armpit of Pennsylvania," with the sole responsibility, as the oldest sibling, of telling me, the baby of the family, that on the fifth floor of Pottstown Memorial Medical Center, our mother was dying.

The only line I have ever really been able to appreciate from Faulkner, akin to this part of life, is a chapter with the solitary sentence: *My mother is a fish.* Now, the water is more familiar.

Interstate 80 in Pennsylvania.

Something in the air around me has told me since the first minutes of that long car ride: that weekend and its timing were not coincidental. I've eliminated "coincidental" from my vocabulary.

Scott waited to spill the news until we had packed the car and locked up my apartment just blocks away from my first place of real solace and fulfillment in my whole life: Clarion University. I had just finished a rough abnormal psychology exam. The semester before, solely inquisitive based on its name, I took a course called "The Sociology of Death and Dying." But if one is not expecting death, even a class on it can't really prepare a person for the real feelings behind that human experience, all its own.

When Southeastern Pennsylvania natives ask me where the college is located, I describe it as between Erie and Pittsburgh but a little to the east.

In the college environment, every subject I studied pulled me in and stirred my curiosities about off-shooting ones, which never happened during high school or earlier years for me. While in Clarion, I excelled, shedding myself from the wall of life, the gray, aired canvas of apathy I'd carved out of my world at home. My time away at college showed me that I could have one good day followed by another, with bad days bypassed entirely. That was new for me.

Clarion is now a set of memories: the pure stink of the pear trees and their white blooms along campus sidewalks in the spring; an abandoned

black umbrella bent inside out from the usual heavy winds, tucked wetly into a puddle after a summer rain; apples chucked hard into chain link fences; a four-foot-tall genital replica made of snow, sitting on the basketball court by Nair and Wilkinson Halls; and the underpaid women I adored working with at the rape crisis center, to which I'd fly down a hilly road past the industrial park after classes on my confused orange-red 1973 Schwinn Varsity, a ten-speed with a crooked frame to its back tire.

At Michelle's Café, with its maroon curtains mid-room painted in gold-embroidered stars, I took to the crowd monthly in hosting open mic nights for the literary journal I ran, *Tobeco*. The room always puffed with an audience and people lining up to read or to sing, and no one could guess as I perkily skipped beats between introductions that I am antisocial at heart, needing my time alone as much as others need to be connected. My connection was always alive because of my disconnection, and as I walked home through the quiet alley after reading a poem inspired by Jenny Lewis lyrics, I felt grateful for the parched-of-light way of the road beneath my sneakers and the noiseless air weaving its way around my ears with every quick-pressing step.

Arguing with a swimmer in ethics class about whether or not rocks have feelings or some type of sentient way about them and for the need to suspend judgment because of not being able to prove this, he protested as I battled out his premises with hard hits in the tricky nature of epistemology. I majored in philosophy.

There is so much I will not remember. The brain struggles within itself in what it thinks it can handle and what it must push out or bury to lean hard toward survival. But even amidst such desperate measures, all reminders point to the fact that I am in Pennsylvania, whether in its armpit or lost in the scent of a mother no longer sleeping in her bed, new curly little chemo hairs scattered across static pillows after an eight-year fight by one tired sixty-year-old body.

<div align="center">⇒•◦•⇐</div>

What I know I will always remember most is the cold. Compared to home, Clarion days were fifteen, if not twenty, degrees more nipped on a regular basis, often with soaking rain in spring and summer and with winter winds that led me to wear all the layers I could find, a scarf constantly wrapped a few times around my head and up to my nose—something that almost provoked

me to once invent an olfactory-swept mitten. The funny thing about my life away at college is, though it is the one experience I will miss most, it made me miss home. I realized late that my mother is my home. Years later, the cold of my mother's fingers turning her favorite hue of a lilac-spent purple haunted my last memories of seeing her unmoving in the fifth-floor hospital room that never was her home before they transferred her to the funeral parlor's incineration site. I never stopped to think of how they would return her to our family as coral-like ash, but now, part of her is in my living room inside a latched-shut ceramic piece; Scott has the other portion in his own living room, while our two other siblings have no remnants, perhaps too scared of what death means to ask for any cut. As her youngest child, the heat of the cremator burning her and the cold of her stilled fingers neglects to make sense to me but glues itself as jutting shards under my skull in the stickiest of stitches. College towns and home, bitingly chilled winter sky and fire with the cryophilic—that is what the prospect of visiting Northwestern Pennsylvania now brings to me. I'm grateful to no longer be able to afford to travel because of pinched time, along with hiking fuel prices, as my excuse.

<div align="center">⊰◈⊱</div>

Once the Nissan began crawling along its route across the interstate again, edging toward home, Scott confessed that with the cancer claiming its final victory after almost a decade, our not-quite-senior-citizen mother's stomach had bloated into a pregnancy-like shape; she could barely eat, and she'd been admitted to the hospital.

For the first time in my life, my brother put his hand over the back of my own, the tires spinning fast underneath us until we broke off that four-hour span and peeled onto the turnpike, an hour from home. My hot tears of that day would continue for several more while I learned what grieving really meant, beyond Anneli Rufus's *The Farewell Chronicles: How We Really Respond to Death*.

As I took slow steps into her dry-of-color room in the bustle at Pottstown Memorial Medical Center, she smiled the smile I never stop missing. She told me she had missed me, and the rest of that line soaked its persuasion behind my eyes in that unseeable place where tears are produced.

Rumspringa

Pittsburgh

By Lisa Ruth Brunner

They trickle in discreetly, tucked behind supermarket coupons with return addresses no household member has ever visited: Amherst. Portland. Berkeley. Greenwich Village. A pile accumulates, glossy and thick.

I am sixteen and ordering college brochures, dreaming not only of schools but also of the vague promise of somewhere better than the fringes of suburban Philadelphia. I envision nothing short of magic: a patchwork of palm and redwood trees scattered across an imaginary city, somewhere brimming with art and leftist politics and competitive universities taking progressive approaches to education. I want states with bold reputations and coastlines, colleges without grades and math pre-requisites. I want the opposite of what I have. I want out.

My parents do not like this pile. They have deep roots in Pennsylvania and staunch faith in public education. What's wrong with Kutztown University? Slippery Rock? A less glossy stream of brochures suspiciously arrives with tuition fees clearly labeled next to subsidized loan details. "Look," my parents announce, "your SAT scores get you into the University of Pittsburgh automatically!" I scowl.

But as much as I fantasize otherwise, I am the daughter of hardworking parents who dream modestly. When acceptance letters come, my parents reluctantly convert a family vacation into a visit to the least expensive of the group: the New College of South Florida, a tiny honors branch within Florida's state university system. As I ogle an African drumming class practicing on the beach at sunset, my parents take note of the smell

of marijuana in the air, unconcealed; the uniform privilege and whiteness and non-conformism of the student body—and, of course, the out-of-state tuition fees. No, my father's eyes plead, do not choose this.

Eventually I am taking an African drumming class after all; it meets in the basement of a converted Jewish community center in Pittsburgh. My parents drive five hours west through heavy sleet to attend the concert. "See," they say, "you did it here for half the price! Aren't you glad? You are glad, right?"

But I have also just taken a literature class with a professor who, as she returns an essay, asks me if I have ever heard of Wellesley. "My daughter loved it," she says off-handedly. "I could see you really blossoming there."

Though a cruel thing to say to a starry-eyed freshman going to a state school for a reason, my heart still soars: there really is hope for me elsewhere, in places with regal names. Pitt will not determine my destiny. Nor will Pennsylvania. I am in a calm before the storm.

<center>⎯⎯◈⎯⎯</center>

As it turns out, Pittsburgh is a great place for students at the turn of the twenty-first century, especially suburban kids learning how to live in a city. My friends and I rent dirt-cheap apartments and drink dollar beers at bars, growing calf muscles strong from biking the hills between the two; we feel invincible. A special program at Pitt lets students attend local cultural events for free, and we participate indiscriminately but passionately, bouncing from operas to experimental films to art openings. Just after Pittsburgh is voted America's "most livable city," the Steelers win the Super Bowl. Most of my friends are either fellow imports from eastern Pennsylvania or punk kids too cool to care about sports, but we still scrounge around for yellow and black clothes and watch in awed amazement as the Steeler Nation rears its euphoric head.

But behind the Terrible Towels lies an undeniable inferiority complex. Even billed optimistically as the "West Coast of the East Coast," Pittsburgh feels on the periphery of everything. Friends in other cities seem so surprised when we insist it's fun; we begin to doubt it ourselves. Maybe Pittsburgh *is* too small. Maybe bigger East Coast cities *do* have something more. When the intention behind the special cultural program we have grown to love is revealed—to keep Pitt graduates in the city—we take a second look. There really are too many graduates scrambling for too few jobs. As friends a year or two older finish school and start to desert us, one by one, we start to get it.

Soon, it becomes almost strange for anyone to think of staying after college. We spend our summers at the Point with one foot in the Allegheny River and one in the Monongahela, shooing away fireflies and planning our departure. Among my friends, New York City is a daunting but seductive option; D.C. seems less exciting but dependable job-wise. Philly still holds some appeal for those with Western Pennsylvania roots, but for us from the east, it is almost a failure—too many potential encounters with people from high school. Portland is the less common dream, but a mysterious grapevine feeds us stories of former Pittsburghers who slide into coveted Portland barista jobs and now go tide-pooling on the weekends. Personally, my mind is set on San Francisco, despite never having been to California. I have images of streets where people can dance and be free and no one will blink an eye; something tells me real life begins the second one sets foot in the Bay Area. I am just waiting as I prepare for a city that loves me back; a city of bridges to more glorious futures; a keystone truly holding things together where I belong.

In the end, a few friends buy fixer-upper houses in Pittsburgh for roughly a public school teacher's yearly salary and hope for the best. But once the rest of us hear how easily the teaching-English-abroad route can put off an adult decision for a few more years, we're hooked. I go for the most exotic place I can fathom without giving my mother more than a minor heart attack: Turkey. *This* is where things will begin, I think, as I flip through photographs of Istanbul and picture myself smoking hookah with Orhan Pamuk. I will drink rakı on the banks of the Bosporus with people who have never heard of Pennsylvania and will never look back.

———

Of course, this is not what happens at all. I am assigned not to Istanbul—not even Ankara—but to a dusty *suburb* of Ankara, and teaching unruly teenagers on very little training is more difficult than I expect. I arrive during a drought; there are no riverside cafés in sight. Worst of all, I am given a studio in a building with dozens of other Americans whose mere existence seems determined to ruin my "authentic" Turkish experience.

I am here on a Fulbright grant and am meant to represent all that is good about American youth and cultural exchange, so the question of where I am from is unavoidable. The students are excited to have an American teacher; they hope for Hollywood, New York City, Texas even. I disappoint them with my answer. Their eyes cloud over with vague notions of farmland as they sift through fuzzy memories of U.S. geography.

"Dracula?" someone asks optimistically.

"Wrong sylvania," I say. "Pittsburgh?" This is met with blank stares. "Philadelphia?"

"Allen Iverson!" a boy says, and others nod in agreement. It is 2007, and I don't tell them he is playing for Colorado now, soon to be in Michigan, originally from Virginia.

"Exactly. Allen Iverson. And the Amish," I say, fumbling for something to keep their attention. I suspect I am a descendant of the Pennsylvania Dutch but have never confirmed this; here, I milk it for all I can. I tell them about the parking sheds for buggies at the Lancaster Walmart and *rumspringa*, where Amish youth spend a year exploring the secular world but typically return to their community's traditional lifestyle. The students are bored, dropping like flies. "Bonnets?" I try, drawing a diagram on the board.

"*Hijab?*" The girls balk with disgust. These are secular students from the Turkish urban elite; headscarves are banned in schools. The class eyes me suspiciously. What kind of American am I, anyway?

Good question.

Turkey is lonely and starts to get hard. My Pittsburgh friends—now spread across continents, most living similar isolated, ex-pat lives—discuss our options over the Internet. Going abroad didn't magically offer any solutions to our questions. Where should we go home *to*? Where should we make home? Our dreamy friend-filled Pittsburgh summers suddenly hold some appeal, and we talk of returning, knowing it is impossible. We are scattered now, and there are even fewer jobs. We can't return but don't know where else to go.

During a particularly cold and difficult Turkish New Year's Eve, drunk, I meet a PhD student from Vancouver who suggests a graduate program there. Tuition is cheap and there's funding, he assures me, but I can barely hear anything over the cranking of gears in my brain: *Vancouver*. Pacific Northwest, like Portland, but maybe kind of like San Francisco, too. Mountains and rainforests and a beautiful Golden Gate–ish bridge. But in *Canada*. The graduate school deadline is in two weeks, so I apply, hold my breath.

Half a year later, my flight lands within view of the Pacific Ocean, and it all makes sense: everything was leading to this. Vancouver. British Columbia. The self-proclaimed "best place on earth."

It is not often one see dreams materializing before one's eyes, but for me, this is Vancouver. The coastline and forests are what I pictured for years without knowing it, only now they are speckled with killer whales and snow-capped mountains. Same-sex marriage had been legalized years ago; the death penalty and guns are non-issues. A large official sign across the street from my bus stop proclaims Vancouver a "nuclear weapon–free zone." Pittsburgh and the Super Bowl become a distant memory; Vancouver has just been voted as the most livable city in the *world*, and the 2010 *Olympics* are on their way. I am here to study migration and culture, and the diversity of Vancouver is incomparable. Best of all, the public university I attend has a radical political history on par with that of UC Berkeley.

I ask people what they know about Pittsburgh, and they shrug coolly. The Penguins? Steel mills? I smile in awe; they are Canadian, so of course they know the basics. But not too much. Because why should they learn about Pennsylvania anyway? Why would anyone care about *anywhere* else but this paradise? The fantasy city I longed for as a sixteen-year-old has existed all along, so I claim it as mine. I decide to try and pass for a native Vancouverite who grew up doing yoga and drinking soy lattes and snowboarding after school. It works for a week or so, until graduate orientation when I make a fatal error: asking to drink *wooder*. Er, water.

A head shoots around. "Are you from Pennsylvania?"

I gulp.

"Outside Philly," I say, never knowing how specific to get. "Near King of Prussia. Norristown?" But then I remember we are in Vancouver and stop myself. "Pennsylvania."

Two eyes widen ecstatically. They belong to a fellow grad student in the same university department—Geography—who grew up less than half an hour from me and is a die-hard Pennsylvanian. A true "Philly Girl," she proclaims herself—and, later, in front of the entire department, me too. "Philly Girls stick together," she announces. "We were raised on cheesesteaks. We don't want your sushi and tofu!" I am mortified.

Naturally, we are assigned a shared office and within days it is adorned with Phillies paraphernalia. My identity-shedding experiment is constantly foiled. "Canadians are weird," she says between grading papers. "Thank God I've got a Pennsylvanian around here." Actually, there are quite a few Pennsylvanians lurking in the school—the word about Canada's cheap graduate tuition is getting out among Americans—but for some inexplicable reason she hones in on me. I get a play-by-play of Philly gossip and invitations to game-day screenings of Pennsylvania teams in her living room. I politely decline, but my

foot comes down at a Redskins-versus-Cowboys invitation. Not only do the racist overtones fit awkwardly with our Edward Said readings, I remind her, but also, what does either team have to do with Pennsylvania?

She looks at me like I have just committed treason. "Hello? Ever heard of Donovan *McNabb?*" He is a longtime Eagles player just traded to the Redskins, I later learn. She is silent for a moment, as if she is only just realizing my less-than-enthusiastic Pennsylvania patriotism. Then: "Who *are* you?"

<center>❧</center>

Vancouverites pride themselves on the quality of British Columbia air, so it takes a few summers to notice what's missing. A few trips to Pennsylvania. A few nights in the hammock in my parents' backyard, engulfed in the thick, East Coast humidity. In a flash, I see it: there is no heat lightning in Vancouver. Every bolt has an accompanying thunderclap there. Here, in Pennsylvania, the humidity is different.

More unsettling is the lack of lightning bugs. No Vancouver mother reminds her child to poke holes in the top of the firefly jar so they can breathe. There are no lightning bugs. No cicadas buzzing through the night.

The only thing more astonishing than watching dreams materialize is watching them melt into reality. My honeymoon with Canada ends when I realize that, actually, Pennsylvania *is* a big part of me. This happens in small ways and in unexpected places, like when I am finally, blissfully, in San Francisco's Mission District, eating a heavy burrito in the sun, and remember eating what I now know were pitiful burritos from a nondescript Mexican restaurant in Pittsburgh. It doesn't make sense, but I feel a longing. My heart skips a beat at the sight of a Flyers jersey in downtown Seattle or, more dramatically, a Pirates hat in Tanzania. It really doesn't make sense. I am not a Philly girl or even a sports fan, really. I don't bleed black and gold. But there I am, smiling.

It also happens when I finally start saying that I am from Pennsylvania—a native Pennsylvanian—and am pleasantly surprised by the results. Computer science graduate students remember their friends at Carnegie Mellon University and hikers talk about the infamous rocky stretch of the Appalachian Trail. Artists have always wanted to see the Andy Warhol Museum; have I been there? Sometimes the Amish come up, or Hershey's chocolate or cheesesteak or Primanti Brothers' sandwiches, and yes, I say, that's Pennsylvania. It's not that I miss these things—or even know them

very well—but people want to talk about their connections with what they know of where I am from, and this all has something to do with who I am. Somehow. In some important way.

And then I hear myself saying that yes, I went to the University of Pittsburgh, and there is a pride in my voice. Oh yes, it's a public school. Well, state-related. But still. No, my student loans aren't too big, relatively speaking. Oh yes, I loved Pittsburgh! Still do. Might go back someday. And I think of my parents and respect them so much for pushing Pitt, pushing Pennsylvania. No—giving me Pennsylvania.

Reminiscence and Regret in Portage

Cambria County

By Melanie Wattenbarger

*Family is so important we should all do our best to spend time together
and make memories. Years fly by so fast.*
—*Rose Ann, my grandmother*

Waking up on the fifth of seven hours on the road from our Ohio
home, I was shocked at the drop of the road down the mountain on
the winding turnpike. There was no denying it; we were in Pennsylvania
now, intimately close to the roots of our family. When my grandparents left
their financially burdened families and the failing coal mines in 1961 on the
day after Thanksgiving, they left an entire world behind, one that would
come back to haunt me two generations later, gripping my heart with ever-
strengthening tugs of devotion and despair, pulling me back to the mountains
that made me who I am.

Fifty years after Joseph and Rose Ann left Portage, I returned to make a
vital introduction; it was time for Michael John, my autistic great uncle, to
meet my son, one-year-old Michael William. The tiny kitchen in the house,
one that the coal company sold to my great-grandfather, was filled with
laughter and the smell of halupkies rising with the hot air as more and more
relatives arrived. Michael John was beside himself with joy, periodically
chiming, "Happy Day! It's a Party!"—exclamations along with which we all
could not help but smile.

Michael John and Michael William.

Indeed, it was a happy day. All of us were able to forget the loneliness Michael John and his mentally handicapped older sister endure day after day, tucked alone together into the Pennsylvania wilderness, out of sight and out of mind. We were able to forget our guilt for not coming to visit more often or engage with them since budget cuts ended the local social

programs for the mentally handicapped adult population of the county. We were able to clean the bathrooms, kitchen and living room and pretend for those few short hours that the hired housekeeper was performing her paid duty to maintain a clean house for our dear relatives who cannot clean for themselves. It was a day without regret.

Life with a family in Ohio is hectic, but when I return to the mountains, deserted railways and coal piles, I go to a place where time suspends and slows. I retrace the steps of my great-grandfather—known as "Dutch" or "Mickie" by his friends—whose favorite pastime was walking through the woods. Grandpap would avoid the three-mile road to town so he wouldn't have to turn down the generous neighbors offering him a ride. He was a man of the mountains, preferring the beauty of nature and a fresh breeze to the convenience and rumble of automobiles.

Walking the same path today is different, yet somehow I half expect Grandpap to be smiling, waiting for me around every turn to share a tall tale and show me which mushrooms to pick or tell me the names of the birds twittering above. Most of the railway he walked is now dissembled or buried with random ties and nails loosely marking my way. His old coal-mining spirit still seems to remain in the coal hills I climbed as a child and still do.

A devout Russian Orthodox man, Grandpap taught his family about God and the virtue of being a family. He devoted his life to three things: God, family and the coal mine. Everything he did was to provide for his wife and four surviving children. From buying the house from the coal mine, recruiting his buddies to build another room addition with each child born and working the night shift on the Safety Team in the darkness of the coal pits, he lived out the faith in this trinity every day. Like many children from the 1940s in Portage, my grandmother remembers her father coming home every day, transformed by the black of the coal when the mines were running strong. Even when the mines started to fail in Portage, Grandpap did all he could to provide for his family.

Always faithful, Grandpap questioned why God would give them a child with the challenges Michael John had to endure. As a mother now, I can only imagine his fear and despair at the task of raising an autistic child before autism was a household name, before autism was even beginning to be medically understood. When my great-grandmother passed away, he

Michael John as a toddler.

finally realized "why God gave us Michael; he gives me a reason to get up every morning."

Even as a challenge, Michael John has always been a source of light in our family. He has a way of disarming all of the walls we build around ourselves in life, and he can pull the childish joy from its bondage in our hearts. His love and compassion shine in every moment, whether he's gently stroking and kissing my toddler or shaking toys for him and lighting up when Michael William leans in to hug and kiss him. Michael John reminds us of what Grandpap saw in family: the bonds of family, which transcend generations, time and geography. I am reminded of why I come back to Portage: a longing for those mountains, the pizza of Dough Boys and The Bakery, the incense of the tiny Russian Orthodox church in town.

Slowing down, matching the pace of my elder relatives, I am transported deeper into myself, the land and the roots of the virtues of family. Michael John mixes news of what his neighbors are up to with the stories of fictional characters whose lives he tracks on television. The last time we visited, it took us two days to figure out that the stalker Michael John was talking about was not sneaking through his backyard among the blackberry bushes but was terrorizing the women on *Days of Our Lives*. Even with the mixture of fantasy and reality, memory and presence, he offers a sense of living more deeply and authentically.

<hr />

Living so far away, it is easy to make excuses for why I do not return to Portage more often—work, school, kids and all of the business that life sets on my doorstep. Yet the hectic lifestyle my family and I lead, while thoroughly modern, is exhausting. Too many days of the week, my husband and I are two ships passing in the night, and our entire family seems to be eternally running late for one engagement or another.

The long drive through Columbus, Steubenville, Pittsburgh and on to Portage provides hours to peel away the layers of stress, schedules and obligations. The meandering Pennsylvania Turnpike returns me to following the natural rhythm of the land, much the same way Grandpap taught my grandmother to do years ago. I find a peace in Portage and a version of myself much like what Thoreau wrote about in *Walden*. I have no agenda, no schedule besides attending services on Sunday and, in the meantime, just being part of a family.

Whether swimming at Blue Knob, driving around to take in the new windmills or picking blackberries in the backyard, I am free to follow the whims of my family, all three generations of us. Michael John and Eugenia have simple needs and lead simple lives; stepping into their lives teaches me the timelessness of family and our time together. We are bound by more than familial obligation; we are tied through companionship in the love and laughs we share and the strength we loan during times of trial.

When my great-grandparents passed away, our depth of pain was more acute because of the special places Michael John and Eugenia share in our family. Trying to explain the loss to Michael John in particular is much like the tragedy of explaining the loss of a parent to a young child. He only accepted authority from his parents and relied on their love and guidance

to provide stability to his life. Although he is now over fifty, with all the stubbornness of an adult, he does not possess the full capacity to reason for himself on financial, nutritional or hygienic matters. Besides the struggle to help Eugenia and Michael John mourn the loss of the parents they'd lived with for their entire lives, for the first time we had to face the question that would perennially haunt us: how do we best care for our dear relatives?

Luckily, my great aunt and uncle have found a way to be each other's strength in companionship over the long spans of time between when we are able to visit. They have moved their trust in the guidance from their parents

The author's great-grandma and grandpap's wedding.

to my grandmother and now also to my mother, while another of their sisters, my Aunt Mary, provides basic needs: groceries and meals, transportation to doctors and trips for ice cream.

The entire family pitches in to try to maintain the life Eugenia and Michael John have always enjoyed. Yet we all also share the burden of fear that someday this brother and sister will need to be split apart and placed in some sort of group home or nursing facility, especially as they age and their bodies begin to betray them. While Cambria County does offer group homes for mentally handicapped adults and nursing facilities, it is highly unlikely for there to be two spaces in the same facility for Michael John and Eugenia or that as they age they will both need the same type of services

The author's grandmother, Rose Ann, with her younger sister, Eugenia, and brother, Phillip.

simultaneously. Even if any of us younger relatives decides to open our homes to serve our aunt and uncle, it is unlikely that they would adjust well or that we would have the capabilities to prolong a move into a nursing facility for many years.

※

On sticky summer afternoons, sitting on the porch and watching cars go by, it is easy to fall into the peace of the mountains my family has been tied to for so many generations. As happy as this moment together is, enjoying one another's company while watching Michael John and Michael William share kisses and tickles over a bowl of strawberries, I cannot help but feel a

tug of sadness. It is haunting to be reminded that this simple lifestyle, cozy moments out on the small porch in Portage, may all too soon end for our family. While no sacrifice is too large in the care of relatives, there is a tragic sense of helplessness that I cannot stop the ticking crocodile of time from stealing Eugenia and Michael John away.

Initiation into Paradise

Lickingville
By F. Gregory Stewart

I met Bob on the first day of new faculty orientation. The new faculty cohort was the largest at the university in a number of years, and there were any number of people to get to know. However, the inexplicable workings of the universe put an English professor from Texas in the company of a physics professor from Pennsylvania. I knew Bob was from Pennsylvania because that was one of the things he would talk about with excessive pride. Soon after meeting him, I met his wife, Betsy. They grew up in Warren County and were high school sweethearts. They married after college and had spent the last few years in Philadelphia for graduate work. Now in Fredericksburg, Virginia, they either traveled back to Pennsylvania what seemed like every weekend or hosted friends and family at their home. More times than I could count, I would drop something by that home and be told, "You're staying for dinner." Hospitality was their code; friendship, their virtue.

While at their home, I saw photo albums of different phases of their lives throughout Pennsylvania. Every picture depicted joyous moments, and of those album images, the ones taken at Bob's family's farm in Lickingville most piqued my curiosity. Every snapshot showed a visibly relaxed atmosphere that I noted as I mocked the town's name. The interior of the farmhouse featured Pennsylvania Dutch furnishings similar to the ones that filled Bob and Betsy's Fredericksburg home. I knew the place was special to them not

The farm and barn.

only because of the certain sense of reverence they had when speaking about the farm but also because of their frequent trips there.

Almost two years into knowing them, they invited me to spend the Fourth of July with their families at that farm. By that time, the farm had taken on a mythic quality. We had spent the previous Fourth on the National Mall in Washington, D.C., where we watched the fireworks amid the throngs of other Americans celebrating the country and, unbeknownst to most, the Pennsylvanian motto "Virtue, Liberty and Independence," too. I was waiting with my suitcase for Bob and Betsy to pick me up for a holiday road trip. We went from highways to back roads to a middle-of-nowhere place tucked into the heart of Clarion County.

The town is little more than a series of farms sutured together by paved and unpaved roads. On its outskirts stands a general store, which sells, among other things, a type of bacon Bob prizes, because we had to stop for it. Across that street is an outdoor flea market where vendors sell everything from gently used pots and pans to jewelry to freshly baked whoopee pies.

To claim Lickingville, Pennsylvania, as different than other places I'd known across the country would prove an understatement; to verify the

farm as mythic became easy. It was rooted in family history, evident from the stories of the barn, its support beams and the fire that strengthened rather than destroyed them, as well as the chronicle of my friends' and their families' lives in the pictures that adorned every room. I came to see and know Bob and Betsy in a different way that disoriented me—so much family history was encapsulated and documented in those rooms. Here was a place ripe for escapes—a child's tree house or fort—a place permitting reflection on a world going too fast. Bob has commented that our friendship appears to transcend the time in which we've known each other. I understand that comment against the backdrop of the farm and my small participation in that family history. When there, time worked in a different fashion.

Lunch on the Fourth of July during my first visit to the farm took longer than the most ornate Thanksgiving feast; I know because I've since spent the last two Thanksgivings at the farm, too. The party began as Bob and I sat outside at the picnic table. I was charged with assembling the new barbecue grill while Bob began the comical process of marinating the chicken, the main course. "What do you think?" Bob asked.

"Of the chicken?"

"Of the farm."

"It's paradise," I said. And I meant it. For the day and a half that I had been there, indeed for the first time in my memory, I felt no worries or burdens of expectation upon me. I repeated, "It's paradise."

"No," Bob corrected, "it's Pennsylvania," whereupon, in unison, we said "Lickingville, Pennsylvania," with an emphasis on "Lickingville" to parallel my initial parody of the town's name from over a year ago. Shortly thereafter, Bob's parents arrived. We unloaded their trunk of additional food for lunch and took it to the kitchen. Bob's father joined us outside, until Betsy's parents arrived. Betsy's brother was the last to arrive on that first visit, but Bob's sister and her family would be there with us on the following Fourth.

Several hours of visiting and a lengthy cooking process later, we sat down to eat. I listened, amazed as they shared the lineage and history of some of the food we passed around the table. Family traditions were as present on my taste buds as they were in the conversation. After dinner, we moved outside to play a Pennsylvanian variation of what I knew as bocce, to go for a walk and to continue the visit, all except for Bob, who was busy gathering fallen limbs to build the evening's bonfire. Betsy explained that as soon as Bob's father believed him old enough to handle those duties, Bob had done so with a seriousness normally reserved for clerics or religious ceremonies.

The barn.

With the bonfire lit, we continued our visit around the farm. Betsy's father had just retired at the end of that June from the factory where he had worked most of his life. The reflections he offered suffused feelings of accomplishment and satisfaction with occasional lamentation of the factory's movement to automation and the fear that other employees wouldn't have the luxury of retirement. Likewise, Bob's father, for the longest time the singular nursery owner in their hometown, noted the opening of a chain home improvement store with a large garden center and its effect on his business. Unlike me, they had not been able to watch their worries disappear at the farm.

Bob's mother, a breast cancer survivor, offered optimism, and on my subsequent visits with her, I see that as one of her pivotal roles. She shares that role with Bob's father, and the result is contagious among the whole family. To me, Betsy's mother embodies holiness; she works at the church, but her countenance portrays one mindful of the spirit of God alive and at work in His creation. These were hardworking people who built their lives around their families, but still, they saw their responsibilities as wider. As evidence to that, I was welcomed as family on that day. I saw virtue that day in Lickingville, and I saw it a year later, on my second Fourth at the

farm, when the first words from Bob's mother to me were "You're coming to Thanksgiving." I didn't know if it was a question or a command; I took it to be the latter so was there.

"You want me to what?" I asked Bob's mother after she instructed me to put the stuffing into the cavity of the bird. "I've just met this turkey. Don't you think I should at least get to know it, maybe take it out for dinner?"

I heard Bob laughing from the other room as his mother replied, "It already likes you, now get it up in there." I had to laugh, too, as a host of off-color remarks flew between us.

The later evening of my first visit to the farm brought with it a trip into Warren County and a visit to Warren's downtown. Like Lickingville, it was a place unspoiled by time, a place that people returned to inasmuch as others called it home. I tried to reconcile my own memories at that moment, because I had always believed that I'd come from a small town in Texas. Next to the places that Bob and Betsy called home, mine was a metropolis.

High school friends of Bob and Betsy had a band and were playing at what had to be the only venue in Warren's three- or four-block downtown. When we walked into the place, a crowd of people who all knew Betsy and Bob met us. In a few of the many introductions I went through that night, it was noted that I was "a Texan" or "from Texas," not meant so much as an alienating device but as an explanation for my inherent goofiness. Those introductions brought a wider acceptance into the Pennsylvanian fold. I had the seal of approval from Bob and from Betsy, and for their friends, that remained more than enough.

On the early morning drive back to the farm, Bob apologized for the evening.

"What are you talking about?" I asked him.

"It was a roomful of strangers, which I know makes you uncomfortable. Plus, it didn't mean anything to you."

"That's where you're wrong," I said. The truth was, the whole of the trip meant a great deal to me. To be able to walk into and touch these places that, until then, had been more myth than reality to me only confirmed my appreciation and respect for the people Bob and Betsy are and the history out of which they come.

Apart from the visit to Warren, we stayed put near the farmhouse and the barn for most of the trip, and there was more than enough to occupy us there: the wild clumps of blackberry bushes tamed only by the tracks of a recently mowed field, the barn with its soft hay floor, the long stretch of land ideal for racing Suzy—Bob and Betsy's dog—until both of us were panting. On the final day of my inaugural trip to the farm, we crossed the street.

Across that road from the house lay woods, which meander down a hill to a small creek. The landscape, unsullied by the sort of care and maintenance of suburban lawns, proved a pastoral landscape run amok. Vines stretched across the ground, while rocks and boulders peppered the path to the creek. The antithesis of a farm, oddly enough this part of their property reminded me most of the farm of childhood friends in Texas. It was no surprise, then, that my age slipped away as Bob, Betsy, Suzy and I made it to the creek. As Betsy took a spot on top of one of the larger boulders and Suzy sniffed around, I worked with Bob to find rocks, twigs and other materials to build a dam. Our objective was clear in that bucolic setting: we were to wrestle nature and change the course of the water's flow. And we did; at least for a while we watched with pride as the water first pooled and then began to trickle along its new path. It was not long before the objective changed from creation to destruction. Bob and I hurled rocks toward the central supports of our dam. Again, in an act to master nature, we found time and erosion no match for the unnatural force of the thrown projectiles exerted against the structure we had earlier built. Betsy mocked both of us.

There remains something specific and symbolic in that trip about our respective academic disciplines of physics and literature. I'm no scientist, but I look for meaning in the stories around me. In 1687, Sir Isaac Newton declared, "Every particle of matter in the universe attracts every other particle with a force that is directly proportional to the product of the masses of the particles." If I understand the physics involved in Newton's Law of Gravity—and I don't—it appears perfectly normal that the inertia of our separate trajectories of life would have brought us together to be friends. In reality, the fortunate accident of sitting beside each other at new faculty orientation opened the possibility of a friendship that feels as rich and deep as some of the longest ones I've had, and it brought me to Lickingville, Pennsylvania, a place small enough to remain hidden like a buried treasure awaiting discovery.

In the years since that August morning when we first met and that Fourth of July when I first went to the farm, our lives have continued to unfold. Bob and Betsy had a son and moved from Virginia to Eastern Ohio to be closer to their families; I moved from Virginia to Texas to Tennessee and am preparing to move once again. I talked to Bob the other day, and he said, "If you don't have plans for the Fourth of July, you should come up to the farm." I told him it sounded like the best plan I had heard in a long time.

Steel Country

Pittsburgh

By Geoffrey Beardsall

The invitation to see the Pittsburgh Steelers on October 25, 2009, came on Wednesday; it would be a spur-of-the-moment trip. I had never been to Pittsburgh and was interested to go see this city famous for its steel production. Back home in New Zealand, I worked in a steel mill for many years hauling molten metal and pouring red-hot slag from large haulers. I often went up to the furnace floor and visited with the guys dressed in their full-length aluminum-colored coats, visors pulled down over their faces as they worked amongst the heat and sparks and glowing metal. I heard about the U.S. Steel mill, especially since my wife and I had moved back to Pennsylvania. We lived close to Bethlehem and would drive past the ruins of "The Steel." I'd stare out at the idle plant and buildings where there was once a thriving living, breathing monster mill. I wondered how such a huge and magnificent plant could be silenced. I was intrigued by Pittsburgh and wanted to go and see the city built on the back of the steel industry.

As a Kiwi, American football, which we call "gridiron," is not something I've really watched. I went to a game of high school football when I first came to the United States. So when Rebecca and I were asked if we wanted to go to the game in Pittsburgh, at first I thought, "Are you crazy? All that way to watch football?" But there was no time to ponder the idea, since it was the Wednesday before the game and this wasn't just any football game: it was an NFL game. Besides, I thought, everyone should at least attend one NFL game in his life to cross it off "the list" of things to do before he dies.

The day before, we had left the great metropolis of Philly with my wife's sister-in-law, Tracy, and her fiancé, Steve, at the wheel and headed toward Pittsburgh. The steel capital of the entire world! After passing through many miles of farmland, the highway started to become tree lined as we traveled along. "We must be getting close," I thought to myself. Plus, I was hungry and hoped we would soon get off the highway. My wish was granted as we pulled off the main drag and started to drive through what looked like the remnants of small, rural American towns with many businesses vacant or boarded up. We decided just to pick the next food joint we saw no matter how rundown it might appear.

We took a booth and shuffled in, started looking over the menu. I wondered: what do people eat in Pittsburgh? After all, we were still in Pennsylvania, and the menu looked similar to the ones back home. Go figure, I thought, one would think that after driving west all that way we would at least be in some sort of new world. "Philly cheesesteak, please." At least I knew what that was, though I wondered how they knew what one was since we were so far from Philadelphia. My wife, a vegetarian, had one choice on the menu—salad—but that is usually the state of things in the heartland of Pennsylvania. We all enjoyed filling our empty stomachs, but that is all the food did—satisfy our hunger, not our taste buds. We paid at the register while looking over a monstrous eighteenth-century cash register still on the counter beside the new, sleek, modern digital model. By the look of the place, they had probably been using the former up until recent times. There were no horses outside, but I imagined that should we have stayed much longer, a stagecoach could well have pulled up at any moment.

We spent our afternoon traveling around local wineries in the area. Who would have thought that in a land where it seems to be frozen for a good third of the year there would actually be vineyards? This wasn't the image I had of Pittsburgh. We even visited one vineyard with grapes growing in hothouses. Pulling back onto the highway, we set off for the bed-and-breakfast that awaited us. We planned on staying the night and getting an early start in the morning so we could find parking and take a wander around the pre-game festivities.

After waking up in the morning to a beautiful sunny day—warmer than it had been all October—we drove for a little and then, as if out of nowhere, we saw tall buildings shooting up in front of us. I felt the excitement as we drove past a Steelers tour bus parked outside a hotel. Black and yellow shirts were everywhere as we continued along under the underpasses, where smoke rose into the air from barbecues and families set tables laid out with all the trimmings beside their vehicles. American footballs flew through the

The Pittsburgh skyline.

air, and the atmosphere was one of major festivities. Parking in the right location would be important if we were to leave in an orderly and speedy fashion, so Steve chose the usual spot around Deutschtown Square, where we pulled up. I was told this was the perfect location.

Walking from our parked vehicle toward the stadium, we felt the excitement heighten at street level. We were able to hear the fun and chatter of the thousands of fans who had been congregating throughout the morning. Music played and people laughed, enjoying their mock mini football plays. We walked past groups of fans dressed in purple. The Vikings! I wondered whether they would be safe in the sea of yellow Steelers fans, but the atmosphere was one of peace and goodwill. I even saw families enjoying their freshly prepared hotdogs and chips wearing both Steelers yellow and Vikings purple. Of course, we spotted serious Viking fans wearing the traditional Viking cap with horns.

Our friends told me the stadium expected as many as sixty thousand fans coming to the game. I thought, "That's rather a lot of people and probably back home in New Zealand, there would be very few towns that have that many people in their entire populations." We walked around the whole Heinz Field Stadium to experience the full effect of football fans. At the end of our circuit, we found our gate and went on through the necessary security measures. We walked amongst a sea of people when the woman looked at our tickets and said, "Oh no. You don't go this way." She pointed to the elevators, "You need to go over there." We traveled up the elevator and walked along the corridor looking for our room number. Room number, I thought? Steve opened the door, and then before us appeared a suite like an oasis, complete with a food bar all decked out with an arrangement of various hot and cold meats, salads and fruit, a fridge full of beverages and

Above: Fans twirling "terrible towels" at a Pittsburgh Steelers game.

Below: Three Sisters Bridges in Pittsburgh, crossing the Allegheny River.

large windows that opened to enable us to look right out over the field. "This is the life," I thought to myself, though I wondered what it would have been like to be down in the bleachers. We sat back in our plush leather seats eating some pre-game munchies while watching the stadium fill up and we waited for the game to begin.

The marching band came out, and dancers did their routines while the band marched in various formations. The teams came running out onto the field and went through their warm-up routines, and after a while, a small huddle formed in the middle of the field. I thought we should have brought our binoculars, but I had no idea what to expect when I left, so we watched the large screens to see what the players were doing. Pittsburgh won the toss; the teams lined up in formation. The first kick saw the ball fly up into the air and go down deep into enemy territory—the game was on! The crowd roared, and the yellow team supporters started flaying yellow "terrible towels" around their heads in support of their team's marvelous effort.

After several hours of eating, watching and asking questions, I figured the game was coming to an end because my wife, an avid football fan, was screaming and jumping up to watch the final play. What I remember from the game isn't so much the game itself but the experience of sitting with sixty thousand people all celebrating the game of football on a warm October day. Although I didn't get to see the steel stacks in Pittsburgh, I did get to see the spirit that keeps this city alive to this day. The steel plants might be gone, but the Steelers remain.

Squirrelly in Pennsylvania

Pittsburgh

By Marjorie Maddox

squirrelly *adj.*
cunningly unforthcoming or reticent (thefreedictionary.com)
unpredictable or jumpy…eccentric (allwords.com)
an offensive term meaning very irrational or odd…characteristic of squirrels
(encarta.msn.com/dictionary)

I.

The flyers stun us, spreading their limbs until skin becomes a sail. After a leap and a glide, they parachute among green. Tightrope walkers extraordinaire, they balance on telephone wires, then dive to swinging twigs barely strong enough to hold berries.

Touting their tails like parasols, the gray are the playful pranksters of our youth, the daredevils we no longer dream ourselves of becoming. Arrogant bandits, they tiptoe across backyard fences; clenched between their teeth lie bagels, tea bags, hot dog buns from nearby garbage pails. They scale bird feeders and steal old corncobs, invade attics, dig up bulbs. These paradoxical pals amuse and irritate us. We want to be like them. We hate what they are.

A scavenging Pennsylvania squirrel.

II.

Then there are the extraordinary, those bright in their whiteness that prance across Frick Park and nibble peanuts from our extended palms. Entranced, we praise the albino, delight in the red of its eyes. Its rarity is a prize we crave; for hours, we sit on benches, watching them watch us. We click our tongues and call to them. We organize clubs to spot them. We donate funds to charity in their name.

III.

An overgrown Eagle Scout, my father once hunted squirrel—not in the woods, but on the rectangle lawn of our suburban backyard. That day, I did not hear the crack of my father's shotgun. I still envision the squirrels as unsuspecting, barking no warnings to one another, teasing him with their scampers. Our yard was, after all, *their* territory. They knew the trees much better than we. When I'd rest in the limbs of our maple to read, they'd eye me like a distant relative. When my mother pulled weeds, they'd race between shrubs playing hide-and-

seek. When my father cut the lawn, they'd scurry through the clippings like slap-stick comedians. They made it clear that—in Squirrel Hill—it was merely their good humor that allowed us to remain.

It was only later at the dinner table—after the first bite of meat—that my father told the story of the meal, only then that I learned to swallow betrayal.

IV.

Always a mother, I break for the does crossing our oak-lined streets. My minivan, crammed with children, has learned to slow for chipmunks and raccoons. Most often, though, it's the squirrels, brazen in their jaywalking, that halt traffic. Here I meet the neighbors, all in our cars, waiting for the bushy-tailed to signal the go ahead, to tell us all is safe. Only then do we cross to the rest of our lives.

V.

At nine, my athlete son fears bikes, the skinned knees and over-the-handlebar flips he swears they threaten. He's left his bravado at the ball field. Still, one cool day, I tempt him with after-the-ride treats of ice cream. I lure him to the Great Allegheny Passage bike trails, where wide asphalt and modest inclines make room for his wobbly attempts.

At first, his body is at a forty-five-degree angle, balancing the obstinate frame of red steel. Later, upright, he's quarreling with a rebellious chain that slips whenever he captures confidence. Finally, by mid-morning, he's barreling over the transformed path, his legs churning a type of flight, his sunburnt face grinning fun. This is the happiness I've been waiting for, the joy that whips back his hair and lets him breathe his grown-up freedom.

It's a squirrel that does us in. My son, pedaling pell-mell, tilts his front wheel toward the bike path's only tunnel. It's then the creature darts, zigzags, darts again, then stops shock-still in the bike's path. What can nine years teach a boy but to veer and avoid fur? He forgets the tunnel wall won't budge, won't swerve to his speed.

When handlebars and teeth hit concrete, my son's wail is wild. The unrepentant rodent swishes its tail and stares. "Stupid squirrel," my son screams, once again a small, unsure boy, as he hobbles back, fear returned, toward Pittsburgh.

What the Frick?

Pittsburgh

By Frans Weiser

There is no banner proclaiming, "Welcome to Pittsburgh," but the message is clear enough that I've arrived in civilization when two cars swerve in front of me, impatient to get to the red light directly ahead so they can then wait even more impatiently. I'll let them win that one. In my moving van, I'm no match off the line for the frustrated drivers, who, trying to forget the congestion of traffic lights in Squirrel Hill, accelerate like NASCAR drivers once an open stretch of Forbes Street beckons with two lanes. They misinterpret the posted 35-mile-an-hour speed limit to read 135 miles an hour. No doubt it's an honest mistake.

Suddenly, seconds after another sports car shoots by, it jams on its brakes, forcing me to do the same. My overloaded truck screeches to a halt just yards from the stopped car's rear bumper. The driver is blaring his horn, and it's only then that I understand he's chastising the deer that decided to make a dash from the grove of trees lining the south side of the street over to the community garden that occupies unused space in the Homewood Cemetery. Ominous symbolism at best, yet the deer has made it. The driver rolls down his window to curse the animal for good measure, as if the deer were clearly at fault, yet it's not sticking around to swap insurance information.

It's December 31.

The end of a year, or the beginning, depending on one's perspective. I've been told that in a few hours the cultural district downtown will host the annual fireworks of First Night, yet the fireworks I've just witnessed nearly signaled the last night—of driver and deer.

Welcome to Pittsburgh, indeed.

For many commuters, the brief glimpse of trees in the valley below afforded from Forbes Street, as it splits North and South Frick Park and arrives in Regent Square, is the closest they'll ever get to visiting the park. Pittsburgh isn't known as a walking city. Indeed, its twentieth-century expansion is tied to dependence on the automobile. It is cars, in other words, that make the city move, although anyone who's had the misfortune to experience the Fort Pitt Bridge during rush hour could be forgiven for not being convinced of this statement. That said, I'll only discover this myself after several weeks in the city, not on my first day.

Yet, perhaps now more than ever, Pittsburgh is a city that can be walked. And more importantly, walking has developed into the best way to understand the city. One reason is obvious: we can see other people rather than gaze at our own reflection in their tinted windows. And nowhere is this more visible than in Frick Park, the one below the Forbes Street Bridge, the once overgrown space that has benefitted from the 2006 restoration of Nine

Frick Park entrance.

Mile Run Creek—as I learn from a plaque on one of the trails—and which therefore means passage to the Monongahela River and its unbeatable views.

The first cardboard boxes that I pull out of the truck have my battered walking shoes in them, as I've been dreaming of this open space for the last ten hours on the freeway, and now I plan to follow the deer into the woods. A quick look at Google Maps had given me an idea of the amount of green space in Pittsburgh's largest park before I'd even left Massachusetts with my car in tow, but I am not prepared for "what lies beneath," as the park falls away from reality, existing under the level of street grids and cars. Ironically, though, walking Frick Park exposes the various layers and sediments of the city, in terms of both people and time, both hidden and visible. Like a geologist looking at a fault line to identify the history that has been forgotten, perhaps even covered up after a distant moment of rupture, a visitor to Frick can tell the backstory of the entire city in a matter of minutes.

In the case of Nine Mile Run, however, what "covered up" the past were many million tons of industrial sludge dumped by the local steel mills in the late nineteenth and early twentieth centuries. Yet, phoenix-like, today that mountain of waste has been transformed into a desirable housing development. And just like this example of civic about-face, so many elements of the park act as the perfect metaphors for the city's renaissance. The park is enough by itself to contradict the iron-lung imagery of sunless, smoke-filled skies that many people who don't know of Pittsburgh's charms imagine a post-industrial mill town must still possess.

After just a few box loads up the stairs, I decide to give the ancient central heating in my barren apartment some time to come to life and get the bedroom above freezing. In the five minutes from my front door to the park, I cross through three townships, passing from Wilkinsburg to Edgewood and then back into Pittsburgh. Fortunately, I can't even get lost, as Biddle Street dead ends into South Braddock at a parking lot. There are no kids at the elementary charter school screaming during recess. I'm thankful, as the noise from Braddock behind me is already loud enough, and I'm brain dead from the drive. A line from Robert Frost runs through my mind as I debate for too long something as simple as which path to take.

Heading right, the dirt trail hovers at the upper edge of the ridge for a few meters before suddenly plunging straight down into the valley. Two couples are immediately visible, one stopped by the staircase debating how to navigate the treacherous layer of ice that hasn't quite disappeared from the steps, despite the sunlight pouring down, and the other slowly jogging in matching neon-yellow outfits up a makeshift path that serves as an alternative

route to the stairs. I follow the joggers' lead and make it down to the base of the park with minimal slipping, amazed at how quickly the noise of the city drops away. The so-called Tranquil Trail here is a misnomer. It's on this central artery of the park that most owners let their pets loose, and despite the cold, there are plenty of sightings of both types of animals. Within a few minutes, a puppy has jumped up to give me more than one set of paw prints on my pant legs. Some owners apologize or offer up a half-hearted explanation that their beast is harmless. Others shoot me glances as if *I* could be the threat to their dogs. But these are not the only obstacles on the course. Visible side by side are generations of the city: a grandmother on cross-country skis forces me to swerve quickly, and soon after I jump out of the way as two kids come shooting down a small slope in their sleds.

Pittsburgh's existence seems to have escaped notice of much of the country. It's not East, but not West either. Just like the city, the park is its own microcosm, a hidden gem. How many times during the first weeks of January do I tell Pitt graduate students that I live on "the other side of the park" from Squirrel Hill, only to be shot a terrified look as if I were Christopher Columbus suggesting that the earth were not flat?

Indeed, this limbo between urban development and wilderness could be one of the few places in the city where Steelers' jerseys aren't readily visible. Yet there is a different sense of community here. As if we're all closet Harley Davidson owners without our bikes, a subtle nod of recognition as we cross paths or a brief conversation is not uncommon. Perhaps the fact that people aren't afraid to talk to strangers is the clearest indicator of all that we're truly not in the eastern part of the country, although pockets of uncertainty still exist.

I brush away another layer of the city. The forest of naked trees soon gives way to an open meadow. The cattails, though brittle and dry, remain standing as vestiges of the last summer, much like the overpass in the distance, whose generously Stalinesque use of concrete dates it while signaling the city's own industrial past. As if on cue, I-376 looms high overhead, and the roar of traffic invades the silence once present in the northern part of the park. It suddenly seems ridiculous to think of this freeway, on which I drove into the city just two hours earlier, in terms of its nickname, the "Parkway," because it's plain to see that I'm on the real parkway, several hundred feet below. Just to my left now is the Nine Mile Run Creek, which has a couple of landscaped rock dams in place, allowing for briskly flowing water in some sections and for still water and steppingstones in other parts. It's one version of a Zen garden, all water and no sand. Of course, like the rest of Pittsburgh, beauty and ugliness rest side by side. As the creek enters the

park, it first passes through an eyesore of a drainage ditch, but that concrete is a distant memory just a few hundred yards downstream. The water is a brilliant turquoise the color of glacial streams, yet I decide it's better not to think about what run-off chemicals might be providing that effect here.

When I cross under the freeway on the Nine Mile Run Trail, it's obvious that I'm entering a different world, as if crossing under a train track into a different neighborhood within the city. Frick Park technically ends, but a tail-shaped sliver of green extends southward toward the river. There's something else in the air, however. It's not just that brand-new houses stare down from atop their mountain of detoxed sludge, a far cry from the turn-of-the-century brick homes in Regent Square, but also that the number of walkers begins to thin out. Gone are the day-tripping couples and the expensive exercise gear. Folks here are hard-core walkers in this liminal zone, with little time to look up or around. Nonetheless, they're still good for a "Hello" or "Nice weather." After crossing to the other side of the creek on an overpass in miniature—a foot bridge—the dirt trail peters out like the Colorado River just a few steps from the Gulf of California. At Old Browns Hill Road, concrete reconquers nature, and I have to take the street for a few yards in order to pass under real train tracks. In this case, though, the other side is where I want to be.

It's spectacular. The view, that is. The Mon River changes colors before my eyes, a long-exposure photograph. As the sun is partially covered by clouds, the dark blues shift into a coolant neon green hue, almost as if a thin sheet of ice were forming just below the water's surface. The skyscrapers of the Golden Triangle may never have been built for all I know or care. They're centuries away, around a bend in the river. Although summer is the best time of year to maintain this illusion of remote wilderness, since the foliage will create a tunnel of green that hides the cemetery of railroad cars to the right, when the trees are bare the reflection of the sky on the water is impressive enough so that even the cookie-cutter buildings of the Waterfront Mall across the way on the Southside look idyllic, a series of smokestacks standing as the last remnants of a once-busy mill.

But despite this sign of new wealth and development so close at hand, the Duck Hollow Trail that begins here, or ends, represents another shift in space. It may have been busy in the era of millwork, but now it's almost deserted. I notice that there is no more talking or exchanging of pleasantries. Now the people don't walk their dogs, these solitary men and women who drive here instead of walk the park; instead, they bring the dogs as protection. I pass a woman with heavy eye makeup that I can see despite her enormous

sunglasses. The sunglasses seem out of place, but it's only moments later that I realize why: the sun is disappearing on the horizon, and dusk is falling. I've lost all sense of time. How long have I been walking? An hour? I will have a long way to go if I want to make it back to Regent Square without getting caught in the dark. So I turn around and start to retrace my steps. As I overtake the woman with sunglasses, there is an uncomfortable moment when she instinctively moves over to the side nearest the train tracks as if they were the closest thing to an emergency exit should I turn out to be less than harmless. Having not showered or shaved since my long-distance drive began, I'm not so offended by the idea that I could provide such an image as I am struck but what her reaction means. It's as if now she is the deer and I the car invading what was once her territory, our paths on a collision course.

I don't know on this first day, of course, but I learn fast enough over the course of my first few weeks exploring the city. This path along the river is more than just a little-used trail: it is the space that Pittsburgh inhabits right now. It's a mixture of all the layers, at once old with the ruins of the industrial past immediately visible and also new in that the trail showcases the city's present attempts to revitalize what were once physical barriers between distinct worlds of class and race. The trail is still relatively unknown. Not yet trusted. Largely unexplored. It would seem that the train tracks do isolate after all.

And the walkers express this new collective moment unconsciously.

If the north side of Frick Park leads into the comfortable affluence of Point Breeze, signaled by a finely landscaped stone wall and entrance, it is also bordered by the Homewood Cemetery. On Frick's south side, there are not so many physical barriers as social ones, and rather than the death of the cemetery, there is a raw buzz of potential energy.

Duck Hollow Trail, which is wider than those trails that populate Frick Park, becomes packed with tension when two people pass each other. It is a space unsure of itself. It is the same awkwardness produced by invasions of East Liberty's historically black center with boutiques and chain department stores that cater to a primarily white crowd. It is the same moment as when the elevator door closes and suddenly nobody inside knows where to look or how to maintain the conversation that was flowing like the Mon River just moments before. But, of course, the city is itself a process that never reaches completion. Just as Frick Park is no longer an isolated bubble of public space but is now connected physically and temporally to its history of mills along the river, these various new routes, too, will take time to wear down and be shaped by our shoes until they become documentable layers in the urban geography.

Stone bridge in Frick Park.

My return is without incident. The landscape is already more familiar, and it seems like it takes only half the time to return that it took to reach Duck Hollow Trail, the hollow Pittsburgh. I cheat and find a route that leads me to the heart of Regent Square at the corner of Hutchinson and South

Man walking in Frick Park.

Braddock. By chance, I walk into D's Restaurant, which at first looks like the average pub. It's only when the guy at the register explains the restaurant's secret and I walk down a narrow hallway that opens into the famed beer cave that I realize there's a lot more than meets the eye in this neighborhood.

In this park. In this city. It's the kind of empty philosophy that goes perfectly with a beer or two.

After a bottle from the city's version of Plato's Cave, I head back in the dark to my awaiting apartment and a quiet New Year's Eve of unpacking. But away from Frick, I collide with reality once again. Despite the cranked-up heater, the entire place is still frigid. The neighbors across the street already have a party of screaming undergraduates going, and I realize I'm in for a long night. No, there is no salutary banner, but the city has certainly opened its arms.

Welcome to Pittsburgh, indeed.

Grieving Ceremonies

Shanksville

By Helen Collins Sitler

I know a little about grief. Everyone grieves in their own way.
—*Wally Miller, funeral director and county coroner in Somerset County,*
Pennsylvania

It is July 2003. My husband and I arrive via a dirt road—the small sign names it Skyline Road—winding through a tree-lined field. We pass previous incarnations of this land: on one side, a heap of discarded Pepsi vending machines, an odd note of comic relief; on the other, the rusting housings for draglines, reminders that this now green landscape was once a strip mine, the earth gouged deep for the precious coal buried beneath. At the crest of a low hill, the field opens out for about a quarter mile, gently sloping downward to the edges of a hemlock woods. Against the shimmer of July heat, the shadows under the trees look coolly inviting. Just below us stands a small outpost—a gravel parking area large enough for about ten cars and two port-a-johns. Across the dirt road stands a ten-foot-high chain link fence so covered with items that the metal is barely visible. A man wearing a large pin emblazoned "Flight 93 Ambassadors" steps out from a small trailer like those used at the job office at construction sites. He strikes up a conversation, low and soft, with a woman, gesturing while she nods and looks toward the trees. Nearby, on a raised flat spot, two benches are also oriented toward the hemlocks across the expanse of field.

"Is this it?" I think, deciding to leave the camera in the car. Grass. Trees. Nothing else. This day in 2003 is the first time I have visited the place where

United Airlines Flight 93 crashed on 9/11. That day was similar, cloudless and sunny, my husband's nephew's fourteenth birthday. In this field, only a thirty-minute drive from my home, the fourth plane, diverted by rebellious passengers from its intended target in Washington, D.C., cartwheeled into the ground at 580 miles per hour. The right-side wing slashed the earth first, like an injured bird swooping too low to correct its inevitable downward plunge, splitting the plane apart while engines, still fully engaged, drove the doomed aircraft so deep that the black box was found twenty-seven feet down in the crater formed by the explosion. The resulting fireball rose against the hemlocks, igniting numerous small fires. And the black mushroom cloud bloomed, visible for miles around.

I do not know what I expected to encounter on this visit to the crash site. But not this. Not simply the gently rolling ground of an ordinary Western Pennsylvania field. Not such utter stillness. Not whispered conversations that remind me of my father's funeral home with its aura of hushed reverence. Not a place, as in a funeral home, where the very orientation of field, benches and chain link wall of remembrances compels one's gaze—my gaze, my husband's—in one direction only: out across the sloping field where one lone American flag flutters from a fence near the line of hemlocks. There, guarded by the fencing, lies the ground where the plane came down. On this day in 2003, there is much I do not know about the ground beyond that fence and about events after the deaths of the plane's forty-four passengers and crew.

<hr />

Five years later, in June 2008, along with several friends, I have the opportunity to spend a morning with Wally Miller at the Flight 93 crash site. On September 11, 2001, Miller's dual roles intersected. As the Somerset County coroner, an elected position he still holds, he became the local official in charge of the Flight 93 death scene. Like many coroners in rural areas, he is also a funeral director. That role played out as well in the context of Flight 93. This intermingling of coroner/funeral director is familiar to me. My father, too, wore both hats during his working life in another rural, Western Pennsylvania county.

In meeting with Miller, we had expected a short talk at the temporary memorial. To our surprise, we find ourselves inside the fenced area, at the crash site itself. "It's real quiet down here," Miller says. "You're standing

on a grave." The stillness envelops us. As we gaze at the field around us, dumbfounded, overwhelmed by the silent emptiness, a swallowtail flits to a daisy. Deer, turkey and even bear have returned here. Eighteen months after 9/11, when the site was released as a death scene, Miller ordered topsoil to cover the burnt, scarred acreage. Hydro seeded with grasses, the hardy, pink-flowering ground cover vetch and daisies, it blooms now. Guided by his hand, invisible to the thousands of visitors who mourn at this site, life has risen again, phoenix-like, from the ashes of Pennsylvania's Ground Zero.

Learning that this land has not simply regenerated itself is my first realization of the human care that emerged after the trauma of that September day, my first glimpse into the difference between the coroner's science and the funeral director's empathic understanding of grief and mourning. My first hint that what my own father did regularly in his funeral home had very human, sometimes long-lasting implications.

<div align="center">———◆———</div>

The June 2008 visit with Miller begins outside the fence, at the access road nearest the crash site itself, rather than on Skyline Road a quarter mile uphill. As we gather in the knee-high grass, Miller turns toward the fence and the field beyond it. This is where the plane came down, he says, the front one-third in hemlocks, not in the adjacent open field as one might suspect. A storey-high mound of wood chips is all that remains after scorched, broken trees were bulldozed. He points to two utility poles, power lines strung between them. The plane, breaking apart on its lunatic path, skittered under the power lines and between the poles, scorching them, but touching neither power lines nor poles.

We'll walk now, he says. We will circle around the fence to a gate for which he has the key and step out onto that field. We are silent, taking in our journey—through space, time and emotion. The move back to 2001 begins quickly. Before we have even crossed the road toward the hemlocks, Miller stoops and raises something in his palm. It is a one-inch square of metal. "United Airlines blue," he says, showing us the cobalt paint on one side. "This is a piece of the fuselage." We pass it to one another, handling it carefully, like glass, like something hot enough to burn. Debris from Flight 93. We are touching a piece of the plane. Last to hold it, I wonder what I am supposed to do with it before dropping it back onto the ground.

We trek into the hemlock woods, fern growing lush in the understory, on no visible path but roughly paralleling the fence to our left. Birds chirr

overhead. Several of us wearing shorts—it is a sunny, warm day—swat futilely at mosquitoes. It is beautiful under these trees, meditative, a cool and peaceful respite from the muggy day. Strung out in line in a bizarre game of follow the leader, we push forward through fern and brush, always under the sheltering branches of the hemlocks. I recognize patches of violet leaves, their jaunty, low spring blooms already spent.

We pass trees where large green *X*'s have been painted. Those are the trees, Miller tells us, that volunteer searchers climbed, looking for remains— pieces of clothing, bits of human matter, wires and materials from the plane. Cadaver dogs roamed these woods. Though trained in such searching, accustomed to it, the dogs became so overwhelmed with the scents of death among the hemlocks that they could not work.

The tremendous dissonance inscribed in this ground engulfs me. September 2001 is still too close; I feel horror despite the peaceful coolness of the trees. Later, I learn that this area, the circumference around the crash site itself where searchers combed for anything retrievable from the plane, is called "the halo." The term is discordantly appropriate, since this particular halo encircles what is now considered sacred ground.

As we hike under the tall hemlocks that still today cradle remnants, Miller notices more from the plane in small clearings. Under his tutelage, we, too, begin to notice the tangles of wire scattered everywhere among the evergreen needles on the ground. The hemlocks have held their burdens all these years, it seems, releasing them to earth only after heavy snow and rain cleanse them bit by bit from the embrace of protective branches, or the trees themselves, shallow-rooted, topple, succumbing to nature's winds and snow weights.

We hike past two cabins, neither of which was inhabited on that September day. The roof of one still shows burn marks from flaming wreckage that skated across it and came to rest beyond. Windows were blown out and much human matter was recovered from inside. The irony of the halo repeats itself. A local minister owns these cabins within the halo. Somehow the presence of spirituality here seems right.

And then we arrive.

Miller unlocks the gate in the fence, a lock so surprisingly flimsy that we could, I think, have pried the gate open. We step out into a field of early summer's tall grass, graced with buttercups and daisies. Again, single file, Miller leads us away from the tree line, from the halo to the center where one lone bench sits. We stand near the bench on a makeshift platform of plywood placed in this low-lying area that becomes boggy when it rains. Off to one side of the platform, a bale of hay supports two small American flags

and two metal angels, one imprinted with a photograph of one of Flight 93's flight attendants. The angel carries a banner: "Angels gather here." Family members have left these mementoes. On each anniversary of the crash, Miller tells us, families gather on this plywood for a private ceremony.

Tall and lanky, Miller wears jeans, a tattersal short-sleeved shirt and track shoes. Soft-spoken, he is man-in-the-street ordinary. As both funeral director and coroner, he has learned to be background, not foreground. It is hard to imagine him as the spokesperson on national television interviews and in demand by reporters from major newspapers across the country. Yet he takes on the role for us, having had much practice.

He peppers us with factoids of the coroner's science. The iconic mushroom cloud photographed against the clear blue sky bloomed from a fireball seventy-five feet high. The local fire department put out multiple small fires at the crash scene that day. An engine in the pond beyond one of the cabins was the largest intact part of the plane. The combined weight of the people on Flight 93 was 7,500 pounds; only 650 pounds were ever recovered, with 30 to 40 pounds as the most found of any one person. The largest human segment located was a piece of spine about eleven inches long. Every living thing in the crash area was annihilated; even the insects vanished for a year. Effects located by Miller and volunteer firemen scouring the crater and the halo—a ring, bits of luggage and clothing—were lined up in rows at a hangar at a small local airport.

And then, during this grim recital, it happens. Miller the scientific and sterile coroner recedes; Miller the compassionate funeral director emerges. About the hangar, he says, "You could look at people's lives," perhaps thinking about the two Bibles among the rows of debris. He gestures toward a small tree not far from the makeshift platform, planted by a family in remembrance. Given this sometimes-arid ground, Miller made regular stops for a year to water it. It thrives now. Somewhere here, in the days after the crash, a flash of light high in a tree caught Miller's eye. A climber retrieved a single tooth.

Writing for *Newsweek* in 2009, Eve Conant explains what Miller has not fully shared, further evidence of the funeral director who honors the dead by attending to the emotional needs of the living. As effects were lined up at the local airport, remains were being identified. Sixteen of the forty-four passengers and crew were identified using dental and fingerprint records. Families supplied hairbrushes and razors so that DNA testing could further aid the process. In the small, contained setting of Somerset County, Miller, with the help of Armed Forces DNA Identification Laboratory, was able

to identify every passenger and crew member. He was also able to do something families felt was imperative, and which became impossible in New York and D.C: he was able to separate the terrorists' remains from those of the passengers and crew. Painstakingly, Miller saw that whatever remains had been found were returned to each family. One casket sent to a family contained only two items, a one-inch square of skullcap and the single tooth the climber had retrieved from the tree.

Officially, returning remains to the family is the coroner's duty. But within it, I recognize, too, the funeral director. The explosion incinerated the plane and its contents, as Benjamin Forgey reported for the *Washington Post*. With little physical matter to return to each family, Miller acted instead. He made hundreds of phone calls to family members. He has walked dozens of times through the gate with the flimsy lock and across this quiet field with those who chose to come, explaining to each of them what he explained to us, allowing each person who wanted to—who needed to—to sit on the lone bench and look out over the land that has become a cemetery.

After the morning with Miller, overwhelmed and unable to find adequate words, I sent an e-mail to relatives: "I'm still trying to process everything he told us, everything we saw, everything I felt…Mostly I was thinking about Dad." Though my father died ten years before 9/11, it was if he were present in the field with me. Had the 9/11 catastrophe happened in his rural county during his tenure as deputy coroner, my father would have been called to this scene. As if slides have become confused in a slideshow, Miller, my father and the Flight 93 site kaleidoscope together. Somehow they have become interchangeable. The feel of the funeral home in that field, the silent reverence. And the knowledge that my father, too, played the chameleon, shifting between funeral director and deputy coroner.

<div style="text-align:center">≡◆≡</div>

I have written some of this essay in the summer of 2010, on a bench overlooking the field where the permanent memorial for Flight 93 is under construction. The National Park Service expects that the phase of building nearest the crash site itself will open for the tenth anniversary on September 11, 2011. Even amidst the movement of heavy equipment, the chain link fence with the flimsy lock still guards Ground Zero and the halo. That area will remain untouched. An American flag still flutters from the hay bale

near the plywood platform. Other family mementoes, possibly still the angel bearing the flight attendant's photo, catch the sunlight.

Waves of grief assault me as I visit this site once again, as I struggle to stanch tears when a breeze animates the flag on the distant bale of hay, as other visitors from cars licensed in New Jersey, Virginia, Wisconsin and Maryland look out over the construction toward the pristine field and talk in funereal low tones.

Grief specialists write about grieving as acclimating to a changed world. They say that part of acclimating is telling one's story, the old story evolving into a new one, with significant persons missing. The images of a changed world loop back on themselves for me—my father, with this ordinary Western Pennsylvania field, with Miller, working as coroner in a rural Pennsylvania county not so different from the county where my father worked. They spiral across decades, across the north–south axis of the state, across an emotional geography of stillness and of loss. Even after many years, I do not know yet how to acclimate.

Miller walks the field, telling and retelling his story, finding both death and rebirth in the phoenix site of Pennsylvania's Ground Zero. It is, perhaps, his way of coping with loss. The words on these pages may be, at last, my own grieving ceremony. For the losses of 9/11. And for the loss of my father, whose life's work with families in mourning becomes palpable in a silent field in Somerset County.

Author Biographies

JULES ALDER writes, acts, films, photographs and researches. Born a Mainer, she grew up in a pastoral neck of the Allegheny National Forest. She has a BA in journalism from Penn State University but also studied screenwriting at Pittsburgh Filmmakers and film production for a year in the MFA program at the University of New Orleans. An active New Orleans film and theater community member, she most recently completed the short film *Toll Road*, began the pre-production for her next film, *Hotcakes*, and acted in the Shadowbox Theatre's presentation of China Clark's *Women Who Kill*. A winner of numerous essay awards and creative writing honors, she's also currently working on finishing a short story collection and starting a novella.

GEOFFREY BEARDSALL was born in Helensville, New Zealand, where he grew up amongst the cows and sheep. He worked for New Zealand Steel for twelve years. After working at the steel mill, he opened the first Internet café in New Zealand. He moved to Pennsylvania in 2000.

LISA RUTH BRUNNER is a Pennsylvania native currently living in Washington, D.C. Her writing has appeared in the *New York Times*, the *Pittsburgh City Paper* and on National Public Radio's *Intern Edition*.

MARY LEDONNE CASSIDY was born and raised in Erie, Pennsylvania. She received her BA in English from Cornell University, an MLS from Columbia University, an MFA from the University of North Carolina at Greensboro and a PhD from Binghamton University, during which time she lived in Brackney, Pennsylvania. She was a VISTA volunteer and a librarian before she discovered her true calling: teaching. She is at present an associate professor of English at South Carolina State University.

BARBARA GEORGE, originally from Northwestern Pennsylvania, has taught English to high school students in various states: New Mexico, North Carolina, Maine and Pennsylvania. In addition to her studies in art, English and education, she has completed a master's in sustainable systems and is currently working on a graduate reading/writing degree while working with urban high school students on conservation projects in Pittsburgh.

JENNIFER HETRICK, a freelance writer, founded *news, not blues*, a positive-only, hyper-local news publication covering Southeastern Pennsylvania around Berks, Montgomery and Chester Counties. She contributes quarterly to MidAtlantic Farm Credit's in-house publication, *Leader*, along with *Lancaster Farming*, the *Reading Eagle* and *Berks County Living*. On the Internet, she is a food reviewer for the *Perkiomen Valley Patch* site and pens the affectionately known blog "the garden harlot."

MICHAEL HYDE is author of the story collection *What Are You Afraid Of?*, which won the Katherine Anne Porter Prize in Short Fiction. His stories have appeared in *The Best American Mystery Stories*, *Alaska Quarterly Review*, *Ontario Review* and elsewhere. A graduate of the University of Pennsylvania and Columbia University's MFA writing program, he grew up in York and Bedford Counties in Pennsylvania.

MARJORIE MADDOX, director of creative writing and professor of English at Lock Haven University, has published *Perpendicular As I* (Sandstone Book Award); *Transplant, Transport, Transubstantiation* (WordTech Editions); *Weeknights at the Cathedral* (Yellowglen Prize); *When the Wood Clacks Out Your Name: Baseball Poems* (Redgreene Press); six chapbooks and over 350 poems, stories and essays in such journals and anthologies as *Poetry*; *Prairie Schooner*; *Crab Orchard Review*; *American Literary Review*; *U.S. Catholic*; the *Art Times*; *Arabesque: International Literary Journal*; *Seattle Review*; *Anthology of Magazine Verse and Yearbook of American Poetry*; *A Fine Frenzy: Poets on Shakespeare*; and *Hurricane Blues*. She is the co-editor of *Common Wealth: Contemporary Poets on Pennsylvania* (PSU Press, 2005) and author of two children's books from Boyds Mills Press: *A Crossing of Zebras: Animal Packs in Poetry* (2008) and *The Rules of the Game: Baseball Poems* (2009). Her short story collection, *What She Was Saying*, was one of three finalists for the Katherine Anne Porter Book Award, a finalist for Autumn House Press and a semifinalist for Eastern Washington University's Spokane Fiction Book Award, Leapfrog Press Book Contest and Louisiana University Press's Yellow Shoe Book Award. The recipient of numerous awards, Marjorie lives with her husband and two children in Williamsport, Pennsylvania.

PATRICK MANNING is a native of Bradford, Pennsylvania. At the University of Pittsburgh, he earned a BA in writing, religious studies and anthropology. He attended Eastern Michigan University, where he earned a master of arts in literature and a master of liberal studies in social science and American culture. Currently,

he is a PhD student at McMaster University studying immigrant and working-class literature of the United States. His creative and critical works have been published in the *Three Rivers Review*, *DASH*, *Pennsylvania Literary Journal* and *Muzzle Magazine*. He lives in Toronto, Ontario, with his wife and son.

AMANDA LYNCH MORRIS is an assistant professor of multiethnic rhetoric at Kutztown University, a dedicated photographer and a hardworking writer thanks to the influence of her dad and the place called Pittsburgh.

SUE KREKE RUMBAUGH's writing has appeared in *the Bicycle Review*, *Travel Writing Handbook*, *Pittsburgh Post Gazette* and the *Steubenville Herald-Star*. She has performed readings in Western Pennsylvania and Carlow, Ireland. A native of Pittsburgh, Sue is an assistant professor of English at Carlow University, where she teaches creative writing courses, including memoir, writing about place, craft and personal essay. She earned a bachelor of science degree in journalism (West Virginia University, 1979), a master of public management (Carnegie Mellon University, 2000) and a master of fine arts in creative writing (Carlow University, 2009). In addition to writing short pieces of creative nonfiction and fiction, she has a book-length memoir in progress, for which she is currently seeking a home, and is working on a young adult book of fiction. When not sailing, playing tennis or traveling, Sue and her husband, Larry, reside in Glenshaw, Pennsylvania.

HELEN COLLINS SITLER has lived in Pennsylvania all her life. She currently teaches in the English Department at Indiana University of Pennsylvania, where she specializes in composition and in working with students preparing to teach English in Pennsylvania's secondary schools. Her writing has been published in academic journals. "Writing Like a Good Girl" won the 2008 Edwin M. Hopkins best article award from *English Journal*. In addition to academic writing, she writes narrative nonfiction. One personal favorite, "Everyday Wordcraft," appeared in the *Quarterly* of the National Writing Project, and another favorite, "Halloween Ghoul," appeared in the local literary magazine, the *Loyalhanna Review*.

F. GREGORY STEWART, a Texas native, spends many of his holidays in Pennsylvania. Apart from those trips, he has taught American literature at the University of Texas at Dallas, the University of Mary Washington and other colleges. His work on Southern and African American literature has been published in several journals and literary encyclopedias.

THOM TAMMARO was born and raised in the heart of the steel valley of Western Pennsylvania. His poems, essays, reviews and interviews have appeared in numerous anthologies and magazines, among them *American Poetry Review*, the *Bloomsbury Review*, the *Chicago Review*, the *Chronicle of Higher Education*, *College Composition and*

Communication, the *Emily Dickinson Journal*, the *Great River Review*, *Midwest Quarterly*, *North Dakota Quarterly*, *Quarterly West*, the *South Dakota Review*, the *Sun: A Magazine of Ideas* and *VIA: Voices in Italian Americana*. He is the recipient of fellowships in poetry from the Minnesota State Arts Board, a Loft-McKnight Award in Poetry and a Jerome Foundation Travel and Study Grant, and he was named the 2009 McKnight Foundation/Lakes Region Arts Council Fellow. He is the author of two full-length collections of poems, *Holding on for Dear Life* and *When the Italians Came to My Home Town*, a finalist for a Minnesota Book Award, and two chapbooks, *31 Mornings in December* and *Minnesota Suite*. As an anthologist, he has co-edited *Visiting Dr. Williams: Poems Inspired by the Life and Work of William Carlos Williams* (2011); *Visiting Frost: Poems Inspired by the Life and Work of Robert Frost* (2005); *Visiting Walt: Poems Inspired by the Life and Work of Walt Whitman*, a finalist for a Minnesota Book Award (2003); and *Visiting Emily: Poems Inspired by the Life and Work of Emily Dickinson* (2000), winner of a Minnesota Book Award, all published by the University of Iowa Press. He also co-edited *Imagining Home: Writing from the Midwest* and *Inheriting the Land: Contemporary Voices from the Midwest*, both published by the University of Minnesota Press and both winners of Minnesota Book Awards. He also co-edited *To Sing Along the Way: Minnesota Women Poets from Pre-Territorial Days to the Present* (New Rivers Press, 2006), recipient of the 2007 Midwest Booksellers' Honor Award for Poetry and the 2007 WILLA Award for Poetry from the Women Writing the West Association. Other edited collections include *Remembering James Wright* by Robert Bly and *Roving Across Fields: A Conversation with William Stafford and Uncollected Poems, 1942–1982*. He lives in Moorhead, Minnesota, where he is professor of English and director of the MFA program at Minnesota State University. In 2001, he was named the Roland and Beth Dille Distinguished Faculty Lecturer.

MELANIE WATTENBARGER resides in Delaware, Ohio, with her husband and two boys, with family being her full-time occupation. She earned her BA from Ohio Wesleyan University in religion, theology and humanities-classics and is swiftly approaching completion of a master of arts in liberal studies at Ohio Dominican University. A neophyte in the field, this is Melanie's first publication in her pursuits of teaching English in higher education. She is eagerly anticipating presenting in October at the Rocky Mountain Modern Language Association conference. Born and raised in Ohio, Melanie returned to her roots of Portage, Pennsylvania, where her family has resided for several generations in participating in this project.

FRANS WEISER lives in Regent Square, Pittsburgh, as a convenient excuse to bike through the city's two biggest parks on the short commute to the University of Pittsburgh, where he currently teaches as a postdoctoral fellow in the Spanish Department.

About the Editors

REBECCA HELM BEARDSALL teaches in the English Department at DeSales University. She grew up in Quakertown, Pennsylvania, and has lived in various places since 1991, including Scotland, Canada, Montana and most recently New Zealand. She graduated with a BA in English from DeSales University in 2005 and received her MA in English from Lehigh University in 2008. She has fifteen years' experience in freelance writing in the United States and abroad. Her poetry has been published in various literary journals. She is co-editor of *Philadelphia Reflections: Stories from the Delaware to the Schuylkill*. She currently resides in Bellingham, Washington, with her husband and her cat, Myrtle.

COLLEEN LUTZ CLEMENS, a daughter of the Lehigh Valley, is an assistant professor of English at Kutztown University. Along with her poetry publications in *English Journal*, her essay in the anthology *Click* recounts her story of being her high school's first female tuba player. Her essay about her pappy, who worked at Bethlehem Steel, was featured on Philadelphia public radio's *This I Believe* series. She is co-editor of *Philadelphia Reflections: Stories from the Delaware to the Schuylkill*. She currently resides in Bucks County with her husband and two dogs.

Visit us at
www.historypress.net